TO Doreen

TROWBRIDGE
THROUGH TIME
Kevin J. Hartley and
Andrew D. Jones

Andrew D Jones

K J Hartley.

5·12·09

AMBERLEY PUBLISHING

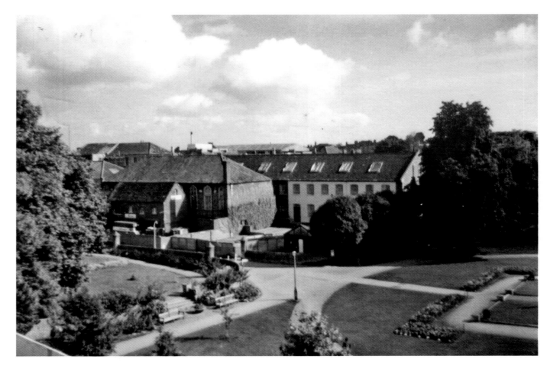

View Across Trowbridge Park towards Hills Hall (1978)

First published 2009

Amberley Publishing Plc
Cirencester Road, Chalford,
Stroud, Gloucestershire, GL6 8PE

www.amberley-books.com
Copyright © Kevin J. Hartley and Andrew D. Jones, 2009

The right of Kevin J. Hartley and Andrew D. Jones
to be identified as the Authors of this work has been
asserted in accordance with the Copyrights, Designs
and Patents Act 1988.

ISBN 978 1 84868 779 0

British Library Cataloguing in Publication Data.
A catalogue record for this book is available from
the British Library.

Typeset in 9.5pt on 12pt Celeste.
Typesetting by Amberley Publishing.
Printed in the UK.

Introduction

It has been said that if our grandparents returned to Trowbridge today they would not recognise the town. That may well be true in some areas of Trowbridge. This book firstly seeks to record some of the many changes in our town in the period between 1970 and 2000, then secondly, giving you a view of Trowbridge in 2009. We have sought in the majority of the older photographs to present buildings which have now gone. The exception to this is the section of shops where the shop ownership and shop front have changed but the building remains.

Where possible, we have taken the up-to-date pictures from the same viewpoint as the older photographs, but where we could not do this, we have aimed to provide an interesting comparison. All of these pictures were taken in the summer of 2009.

Over the past thirty years we have recorded some major developments in the town, the building of the Shires Shopping Centre in the late 1980s and the development of the relief road from Hilperton Road along County Way to Bradley Road, as well as the earlier proposals for a relief road from Hilperton Road through to Timbrell Street, a road that was never built but that resulted in the loss of many buildings in that area of the town.

We hope that this book will bring back memories to older Trowbridgeons and amaze new people, showing how our town has changed in a relatively short time. There has probably been more change in Trowbridge over the last forty years than in the proceeding 200 years.

Kevin J. Hartley and Andrew D. Jones
August 2009.

Bibliographical Note

Both the authors were born and educated in Trowbridge. Over the years they have sought to record the changes in the town.

Andrew is married with two grown up children, he has traced his family tree back to areas of Wiltshire which include North Bradley and Lyneham back at least six generations. Andrew is a founder member of Trowbridge Museum Friends, and has given talks to the Friends and to the Trowbridge Civic Society. He has for over thirty years been a member of Zion Baptist Church, where he is a Deacon, and Youth Leader, and preaches in local churches. Andrew also represents the area on the Committee of The Strict Baptist Historical Society. Andrew has written a number of historical booklets and had a book published in 2007, *Twenty Golden Candlesticks Revisited* a history of local Baptist Churches.

Kevin is married to Marcia. Kevin is a Committee member of Trowbridge Civic Society, and has been involved in producing the society's newsletter. The Chairman of Trowbridge Museum Friends, Vice Chairman of Trowbridge Carnival Committee, a committee member of Trowbridge in Bloom, and a co-opted member of The Trowbridge Town Council Museum and Tourism Committee. Kevin is actively occupied in photographing Trowbridge and its events. Many of Kevin's photographs have appeared in the local press and in other local publications.

HOUSING

Silverthorne's Court (1980)
This footpath, known as Silverthorne's Court or the Drung, still runs from Duke Street down to Roundstone Street. The majority of the houses were demolished in the 1930s and a few in the 1960s. These at the Duke Street end looking towards the *Wiltshire Times* offices remained derelict until the early 1980s. The area at this end of the footpath is now new housing while the rest remains derelict.

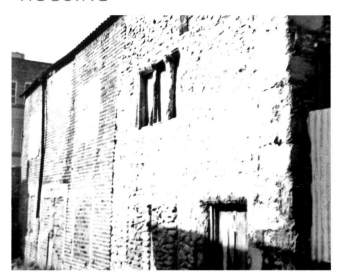

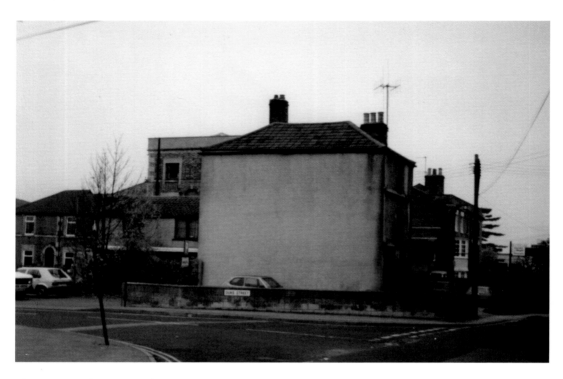

The Corner of The Halve and Duke Street (1984)

The three-storey house shown here at the corner of The Halve and Duke Street would appear to be one of the early houses built in The Halve. Its history and the date and reason for its demolition are both unknown. The area remains empty and is now being used as a car park. The generating station for *West Wilts Electricity* was also nearby.

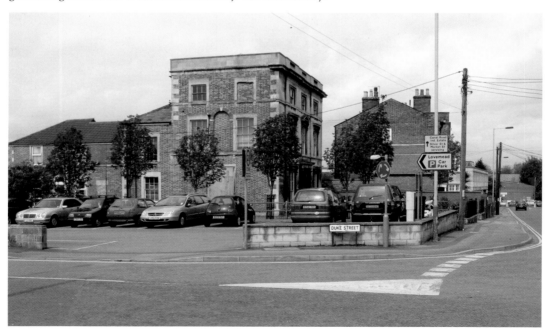

21 Union Street

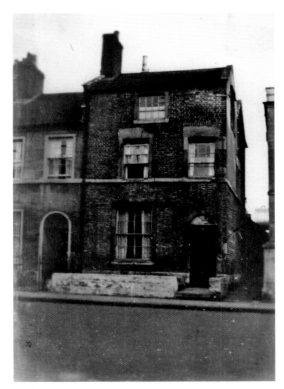

This house was a double tenement next to Zion Chapel, originally part of Barton's Court which was a row of buildings that ran from Union Street towards Duke Street. The majority of these were demolished in 1893 to make room for Sunday school rooms at the chapel. These two were then numbers 1 and 2 Zion Buildings. Number 2 was the chapel caretaker's house from 1930; the two houses were combined in 1947 and became 21 Union Street. David Jones, father of one of the authors was born here in 1932.

The house was condemned and demolished in 1971. The adjoining house (no.22) was later extended over part of the site and was used as Samantha's Restaurant.

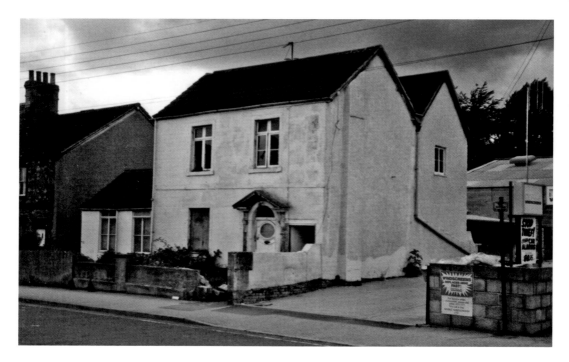

British Row (1989)

British Row is named after the British School that once was nearby. This road was the main road out of the town to Staverton, via The Down before the construction of Timbrell Street. This house would appear to have been one of the original houses in British Row, with a later extension behind. The recent picture shows how the house was rebuilt and also built over the single storey area on the left. The area to the right, now a windscreen repair workshop, was a bakery during the war.

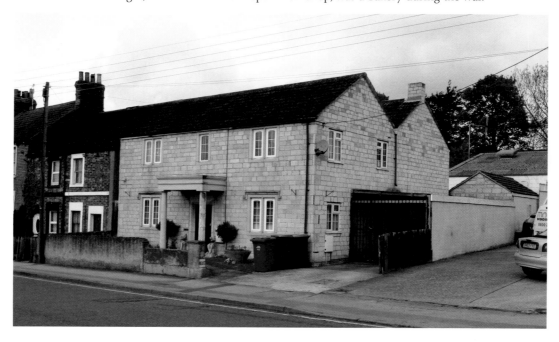

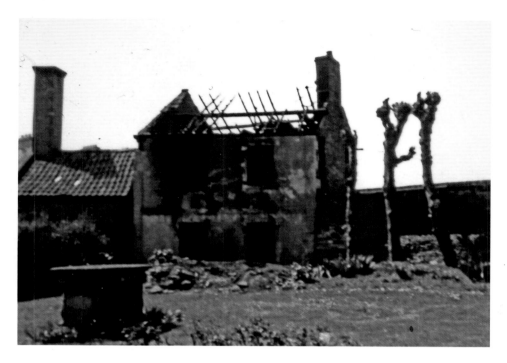

House in St James' Churchyard (1979)

This house was one with which one of Trowbridge's famous sons, Sir Isaac Pitman, has an association. The house was the last remaining building of a number which stood along the churchyard wall. The building was destroyed by fire in 1979. The site now is part of the churchyard.

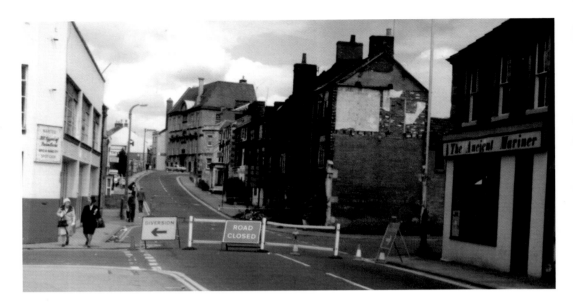

Castle Street (c. 1980)

Castle Street was built from 1820s onwards. An arched entrance to the Market Yard was here. Some homes and shops were demolished for the building of Castle Place and the multi-storey car park in the 1970s; this resulted in the entrance road shown on the right. The houses here were three-storey weavers' houses. These three houses (nos. 51-53) were badly damaged by fire in June 1980 and subsequently demolished with no. 53 rebuilt. The Tale of Spice restaurant, the China Clinic, The Wessex Association of Chamber of Commerce offices , and Trowbridge and District Chamber of Commerce offices occupy this new building.

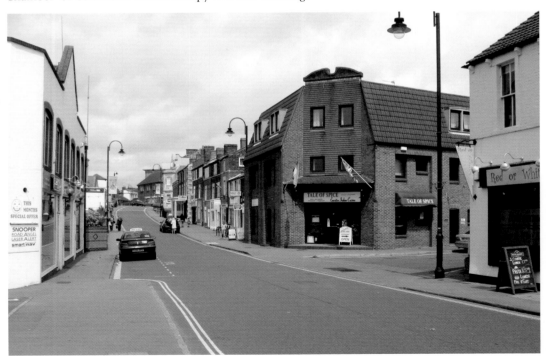

Castle Street (1991)

Over the years the houses which lined Castle Street have gradually disappeared. These two were the last remaining houses on the west side of the street. One is being used by a betting shop. The building on the far left was for many years a car saleroom and workshop trading under the name of C. J. Paffard then rebuilt in 1936 as Barnes Bros. then Ernest Dennis. Later it became a second-hand shop Newbury Antiques, and was rebuilt in the 1990s. The building now houses a variety of businesses; Alpha Taxis, Ilita's and Sextons.

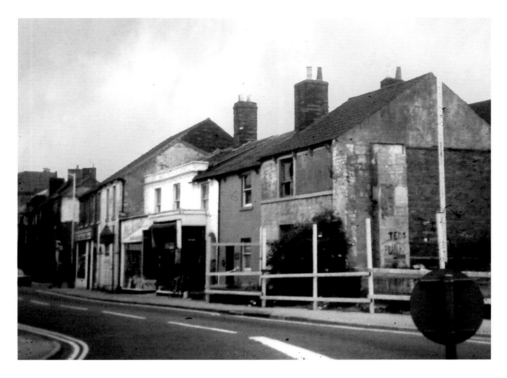

The Bottom of Castle Street (1980)

Further houses extended down Castle Street, continuing into St Stephens Place. The two in our picture were about to be demolished for the building of Knightstone Court in 1981/82. A plaque records the opening 'By Dennis Walters MBE. Member of Parliament for Trowbridge on July 9th 1982 marking the opening of Knightstone Court'.

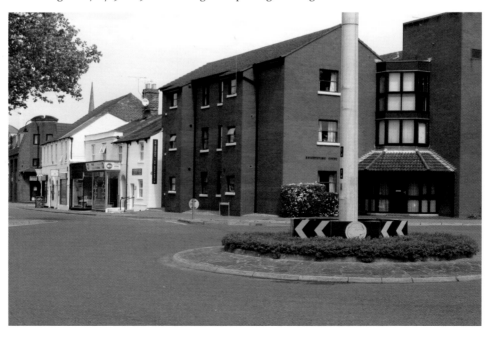

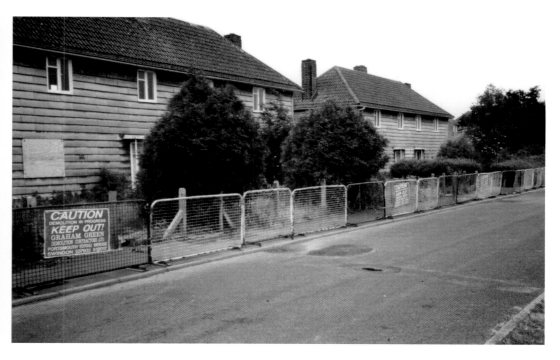

Cherry Gardens (1992)

The majority of the houses on the Longfield Estate were built between 1935 and 1939. The houses seen here were of a post-war construction, and although the pre-war houses remain these were demolished to be replaced by newer homes.

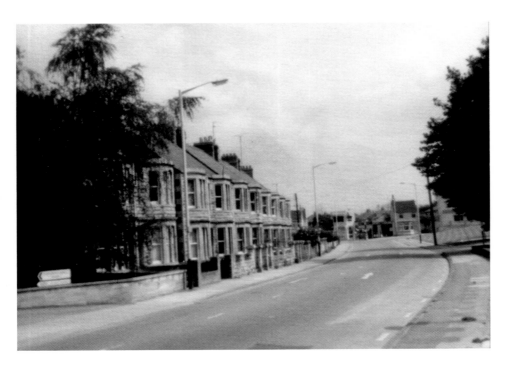

Bythesea Road (1980)

This fine row of Edwardian houses opposite County Hall stood until 1985 when they were demolished, after much public outcry, to facilitate the changes in Bythesea Road and provide additional car parking for County Hall staff. The road layout is so changed that this area is almost unrecognisable.

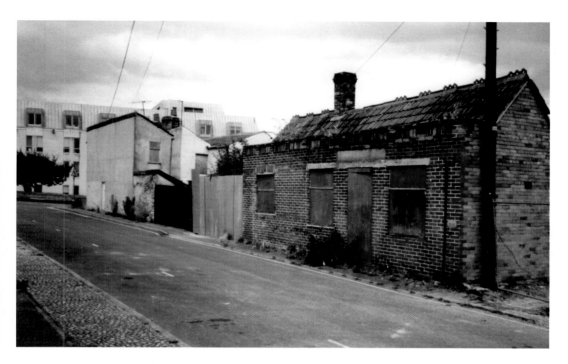

New Road (September 1998)

The building on the right was, from 1935 and into the 1950s, Lovas fish and chip shop. Later it became an area where ice-cream vans were garaged. The majority of the area has been re-developed with new housing, and only five original houses in New Road remain. The 1974 extension to County Hall is visible in both photos.

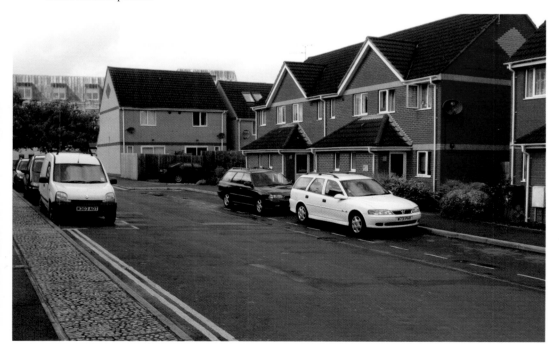

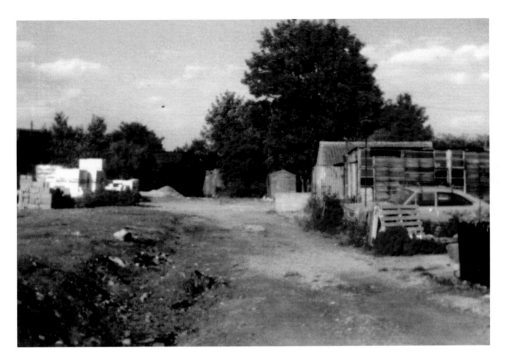

Innox Mill Close (1984)

The area behind the row of houses at the bottom of Innox Road was for many years a scrapyard, which closed in 1969. A flour mill was adjacent to the river Biss, but by the 1960s this was derelict and this has now disappeared. The present houses in Innox Mill Close were built in 1984 and the imminent building work can be seen on the left. The only remaining building in the modern photograph is the garage on the far right.

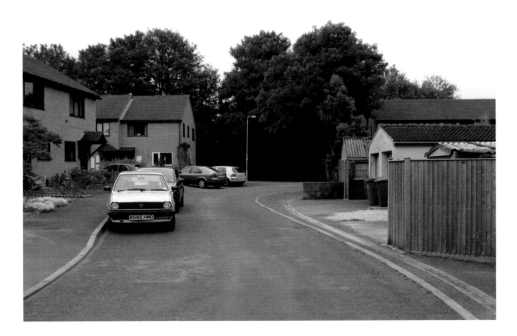

BUILDINGS DEMOLISHED ON THE ROUTE OF THE PROPOSED INNER RELIEF ROAD

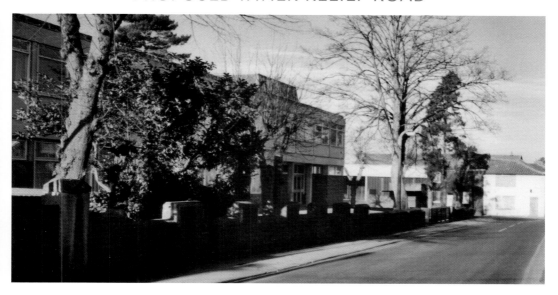

The Halve

This road was widened in 1989 as part of the route of the proposed Inner Relief Road. The building visible in the picture is the Trowbridge Family Health Centre (The Halve Clinic), built in 1963, replacing a building of 1883 which was the town's cottage hospital until the opening of the present hospital which was opened in Adcroft Street on 11 September 1929, by the Marquis of Bath. The two houses in the older photograph have also disappeared.

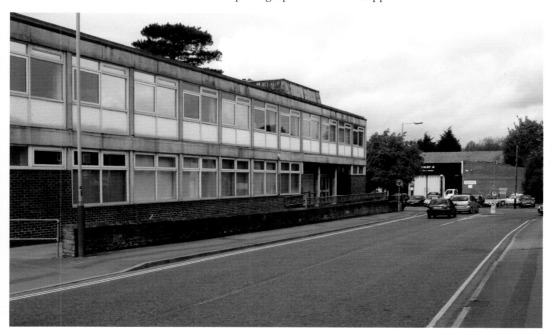

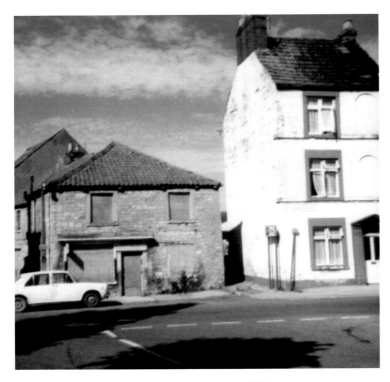

Overton's Shop in Union Street (1980) This shop was at the junction of The Halve and St Thomas Road and took its name from Henry Overton who owned it. Known to the locals as 'Henrys', this closed in March 1977 and was demolished in May 1980, as part of the route of the proposed Inner Relief Road. The three storey house was demolished a little later. The site now remains undeveloped.

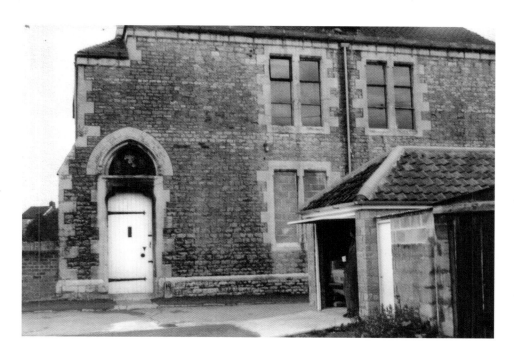

The Armoury

Behind Overton's shop a footpath, named St Thomas Passage, or (previously) Brickplat, leads to Timbrell Street. Among the buildings here was the Armoury, a building which dated from 1871, designed by the local architect William Smith. This was a sweet factory from 1937 until 1973, when Leonard Thickett, the last sweet maker working for Wilkins, retired. It was demolished *c.* 1984; as part of the route of the proposed Inner Relief Road. The end of the garage is visible in both pictures and the pavement shows where the building once stood.

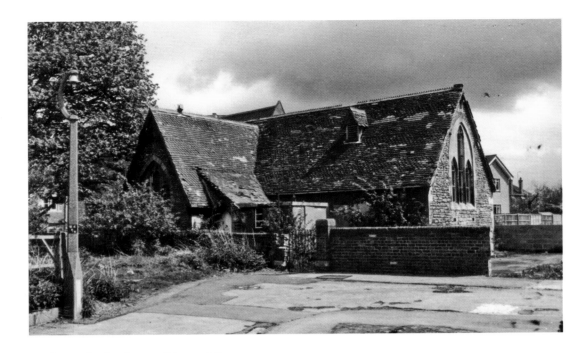

St Thomas' Schoolroom (May 1986)

St Thomas' Church was built in 1870 and the roof is just visible in the background of the older photo. A small spire existed until 1970 when it became unsafe and was removed. This schoolroom was also built in the churchyard, and was also designed by William Smith, as was a verger's cottage. The schoolroom was demolished in November 1988. The 1960s rectory is seen in the background but is obscured by the trees in the recent photo.

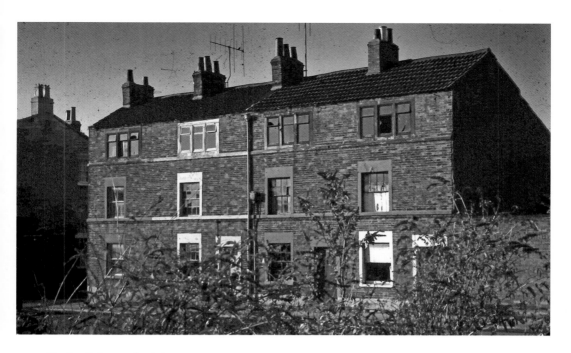

Timbrell Street (1980)

To the west were Thomas Street, Cross Street, Charlotte Street, Poplar Yard and Prospect Place, and to the east York Buildings and Arch Yard. By 1821 this area contained 139 houses.

These three storey weavers' houses on the east side of Timbrell Street stood near the Crown Hotel. For some years they stood empty and derelict until they were demolished in 1980; as part of the route of the proposed Inner Relief Road.

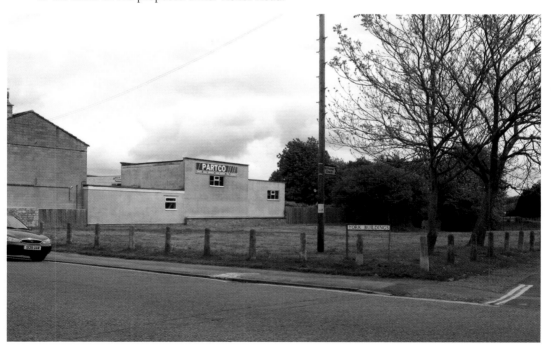

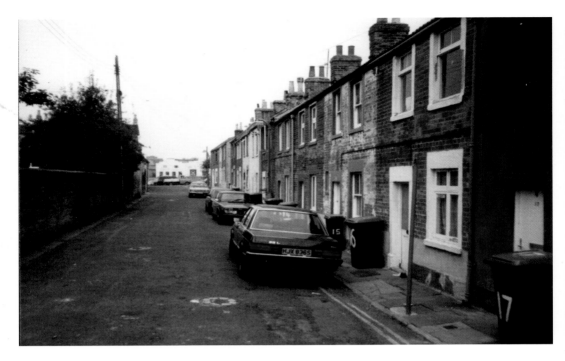

York Buildings (1978)

This single row of terraced houses stood on the grass area leading to St Thomas' church. They were demolished in 1980, leaving one house remaining. At that time it was reported that there would be 'within about five years a massive roundabout and link road here'. In the background is the Modoluxe Laundry, which opened 1934 and closed in 1979. The wall, pavement and circular manhole cover remain.

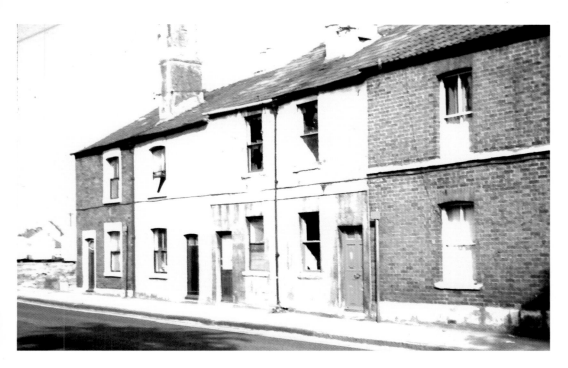

Prospect Place

This row of houses stood opposite Adcroft Drive and the Adcroft Surgery. The far side of the row has already been demolished. Ken Hartley, father of one of the authors lived in the house with the blue door from 1963. An area of paving stones now remains which used to be the entrance to Thomas Street. This is the only evidence that houses once stood here.

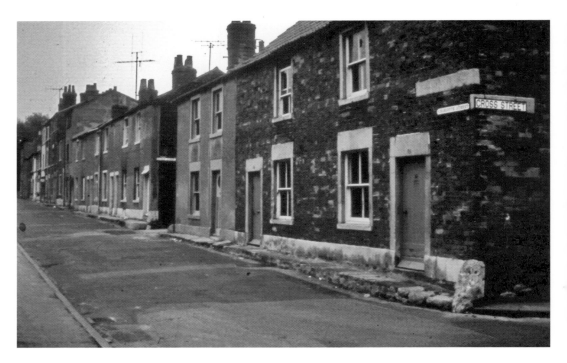

Charlotte Street (1964)

This is another view newcomers to Trowbridge will have difficulty in recognising as all the buildings have been swept away. The picture looks from the end of Cross Street to British Row; Charlotte Court now occupies this area. In the distance is Adcroft Villa (c. 1860).

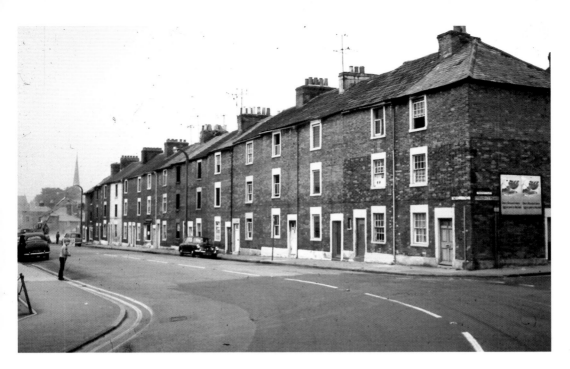

Timbrell Street (1971)

Thomas Timbrell was Lord of the Manor when Timbrell Street was built. The houses on the west side of the street were demolished in September 1971. The Charlotte Street Flats and Group dwelling opening in 1975 are seen in the modern photograph.

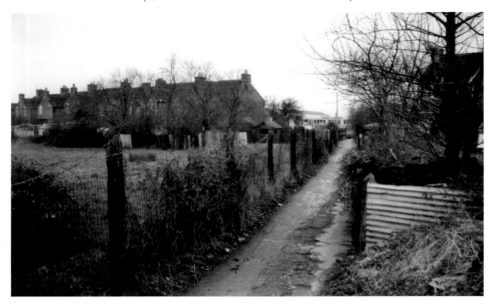

The Footpath to the Football Ground (1988)

This foot path was from the corner of Dursley Road and Mortimer Street leading to Bradley Road. The Towns' football team opened a ground here in 1934. The last match took place on 3 May 1997 when Trowbridge Town played Erith and Belvedere. Almost all of the footpath was swept away by the construction of County Way, the Inner Relief Road. However a small part remains near The Longfield Stone Co. office (Mortimer Street). This small building had several previous uses including a butchers, and a coal yard office.

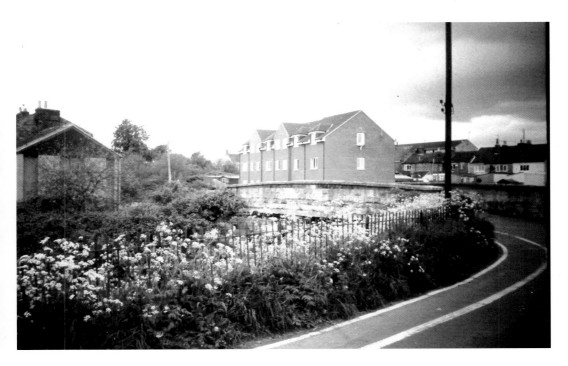

Railway Bridge (New Road)

The original railway bridge here was replaced with a wider bridge to carry County Way (A361), the Inner Relief Road, over the railway and was opened on 3 November 1992 by Cllr Mrs M. Whitworth. The contractors were Costain & Civil Engineering Ltd. The houses on the far left and far right are still standing.

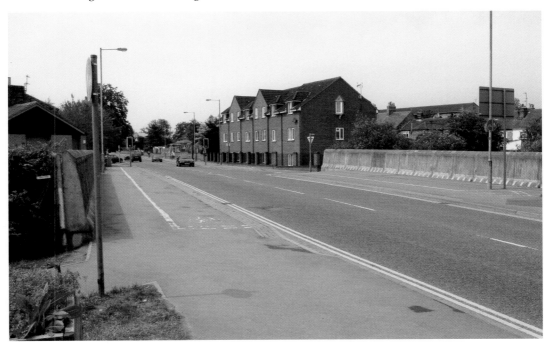

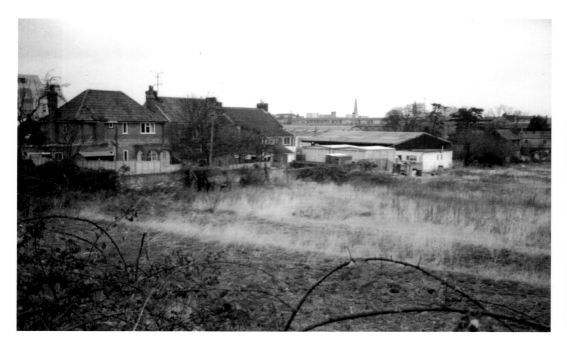

Allotments at the Back of New Road (1990)

This was the last part of the inner relief road, built between 1991/2, which went through these allotments taking the road from Longfield Roundabout to Bradley Road. The house in New Road is visible in both photos. The Parish Church spire shows the top section missing as it had been blown off in the great storm of January 1990. Few people who drive up County Way would realise that, years earlier vegetables once grew here!

The Roundabout at the Junction of Polebarn Road (1984)

Before the construction of County Way the only access to West Ashton Road was via Polebarn Road from the junction in Roundstone Street. During the building of the road the discovery of a bomb cache in December 1983 delayed work. Other roads where homes were demolished due to the relief road included parts of Ashton Street, Hilperton Road, Harford Street, and all of The Furlong. The first link from Hilperton Road to Polebarn roundabout opened on 14 December 1984.

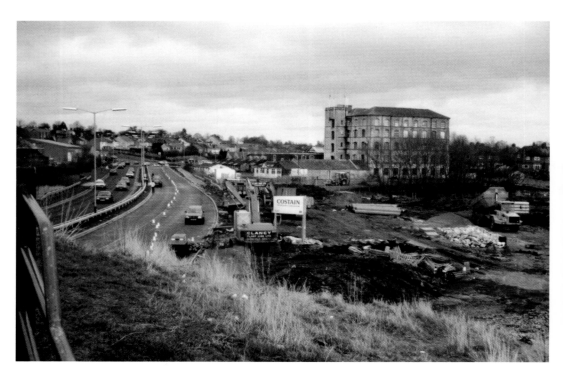

The Tesco Site (April 1992)

Following the building of County Way a new Tesco store was built on the site of the swimming pool. (see page 28) The traffic lights on County Way were installed to assist traffic into the new store.

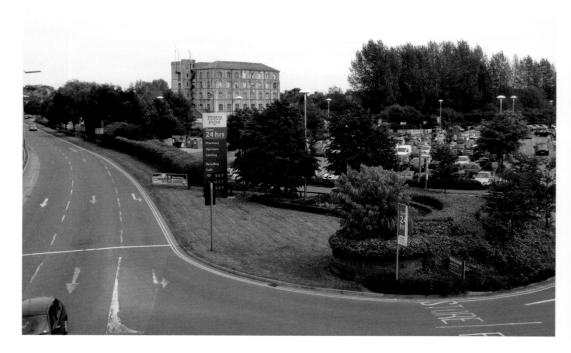

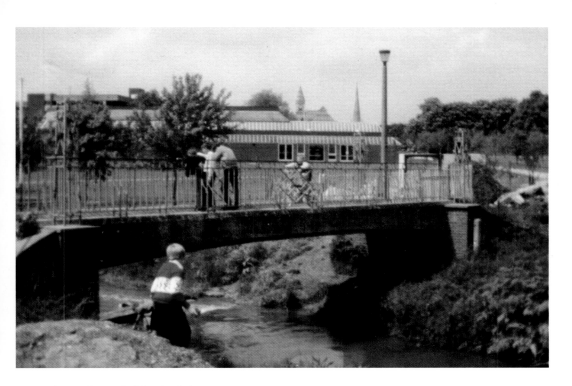

The Park Footbridge (1984)

This small footbridge was built over the river Biss at the bottom of the Park, in 1939 to provide access to The Longfield Estate and new swimming pool. In the background the multi-storey car park can be seen (1973) and the Civic Hall (circa 1974). The bridge disappeared in the redevelopment of the lower park in 1985, due to the construction of the relief road. The new footbridge bridge cost *c.* £80,000, and was further extended when Tesco opened.

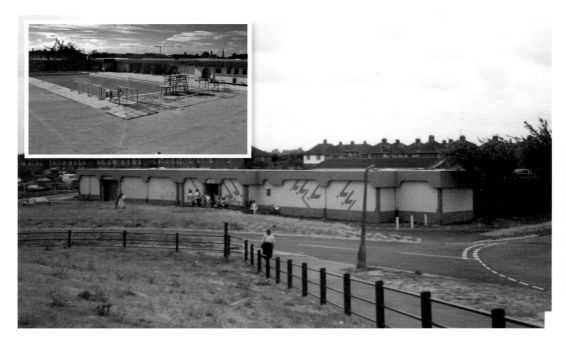

The Swimming Pool (August 1989)

The town's first swimming pool, in Brown Street, was opened by the President of the Wilts. Amateur Swimming Association, on Saturday 13 May 1939. The cost of the construction was £8,000. The main pool was 100ft long with diving boards and there was a small learner pool. In recent years it was modernised at a cost of £150,000 and the water was now heated. The main contractors were Mould and Foreman. The pool closed in 1989 and Tesco now occupies the site.

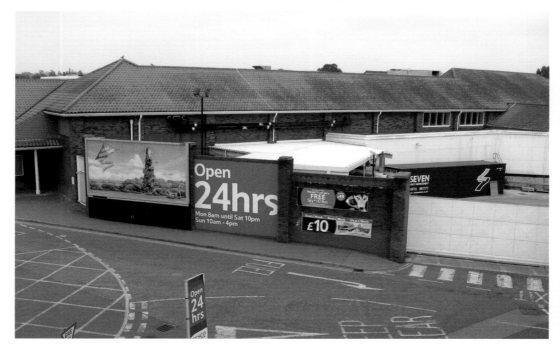

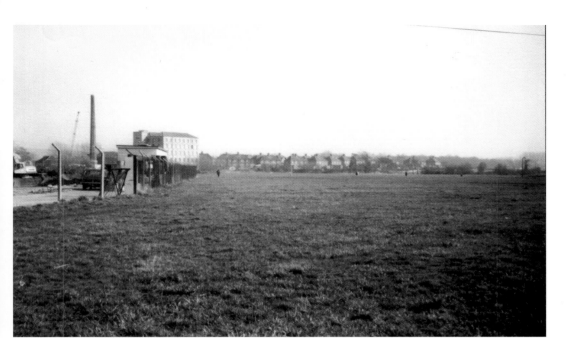

Brown Street (1984)

This area was beyond the lower part of the park, and the river Biss. It was the traditional site for the Fun Fair and Circus visits to the town. Ashton Mill is visible in both pictures. This was the final section of the inner relief road from Polebarn to The Longfield roundabout this opened in autumn 1985. The swimming pool (page 32) was off the picture on the right hand side centre. The boundary fence of the old Peter Black premises remains.

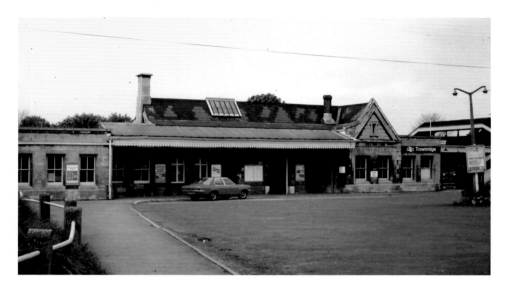

Railway Station Forecourt (1984)

The Wilts Somerset and Weymouth Act of 1845, enabled The Great Western Railway to reach Trowbridge in September 1848, when the station was built. The majority of the buildings on the present Bath bound platform were demolished, together with the signal box, in 1969. During renovations in 1984 the remaining station buildings were found to be unsafe and were also demolished. The replacement station buildings were opened in 1988 at a cost of £250,000. Both the views show the pavement and metal railing on the left.

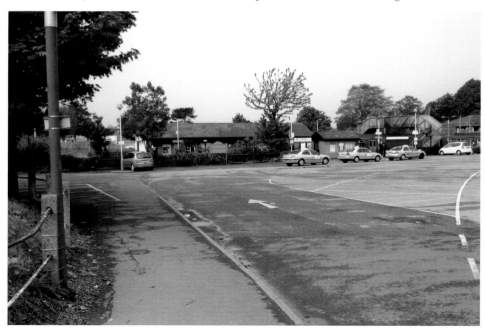

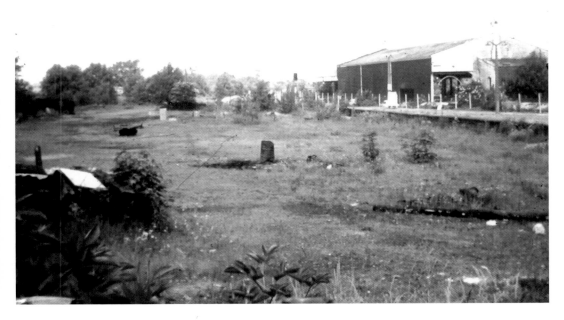

The Coal Yard near the Station (April 1985)

This photograph shows the former coal yard near the station. The entrance was in Innox Road and it traded under the name of Thomas Usher. The firm also had a yard in Bond Street. Jim Loveday managed the yards from 1935 until his retirement in September 1980. The Bryer Ash Business Park now occupies this area.

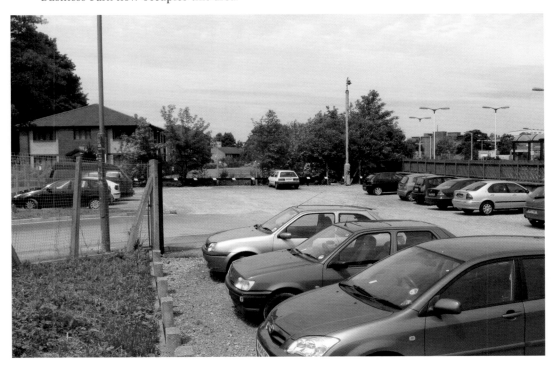

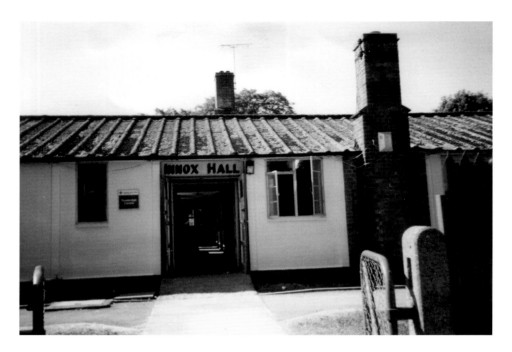

Innox Hall in Innox Road (1995)

Innox Hall was opened in 1941, built on part of the Flower Show Field (now Stallard Playing Field) as a war workers' rest centre. This building provided facilities such as a social area, hot baths and a British restaurant, for those billeted in the town and engaged in war work, mainly Spitfire production. After the war the centre developed into a youth and community centre, even having its own football team in the 1950s. The building was used by many community organisations until its demolition in September 1998.

Adcroft School in Timbrell Street (1994)

Built in 1912 this became Adcroft Boys' School in 1913, and a senior boys' school in 1931. The school closed in 1940 when the pupils were transferred to the new Nelson Haden secondary modern school. Adcroft was then taken over during the war by the Hammersmith School of Building and Art and Crafts, a boarding school, teaching the building trade. After 1945 the County Council then ran the School of Building. After the Building School closed the school was used as a teachers' centre, and by Trowbridge Technical College for a period.

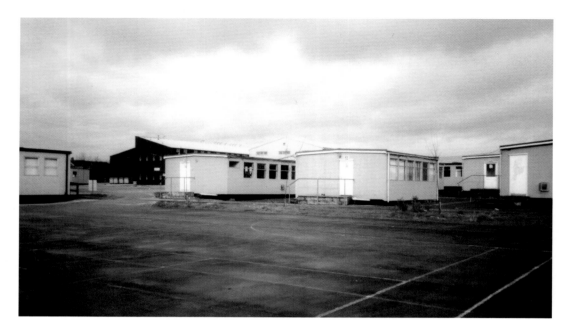

Trowbridge College (Kennet Building)

The first building on the site was the workshop block (Cheverill Building) which opened in Easter 1958, which was followed by the building of the teaching block (Ashton Building) in 1960. Trowbridge College of Further Education was officially opened on 15 July 1960 by Professor J. B. Speakman, Head of the textile department at Leeds University. In June 1994 the Kennett building was constructed, and the contractors were Ballast Needam. The cost was c. £1.5 million. The official opening took place on 8 September 1995, by Sir William Stubbs.

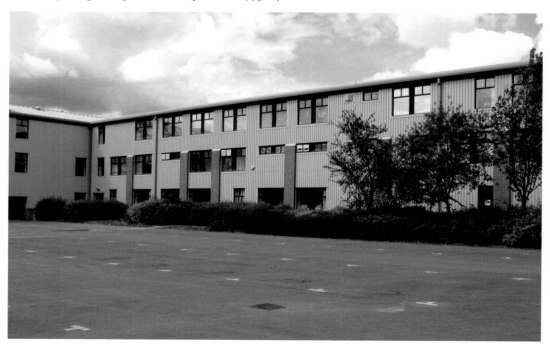

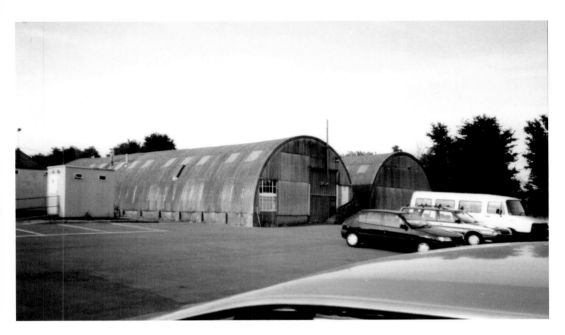

The College Annexe on Frome Road (1995)
The college used these Nissan huts (on the former Wiltshire County Council site in Frome Road), for teaching heavy and light vehicle mechanical courses. In recent times the buildings were used for various subjects of the curriculum including first aid, building trades, retail and pottery. The land was sold after 1996, when the present houses were built.

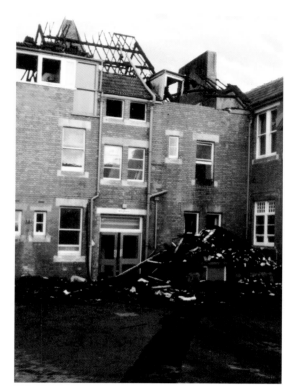

The John of Gaunt School, Wingfield Road (1984)

The main Wingfield Road block was built in 1890 as home to the Wesleyan boys' boarding school, which closed in 1912. The boys of the Trowbridge County Day School who were taught in the Victoria Institute which moved to Wingfield Road the same year. The Trowbridge Education Committee paid £3,500 for the building. The girls stayed at the Victoria Institute, being taught in an unsuitable environment until the opening of the Girls High School, now part of the present site, in 1932. The boys' and girls' combined in April 1969 to form the Trowbridge High School, which became the John of Gaunt School in August 1974. The Wingfield block was the target of an arson attack on the night of 9 February 1984, and the rebuilding was completed in the November of the same year.

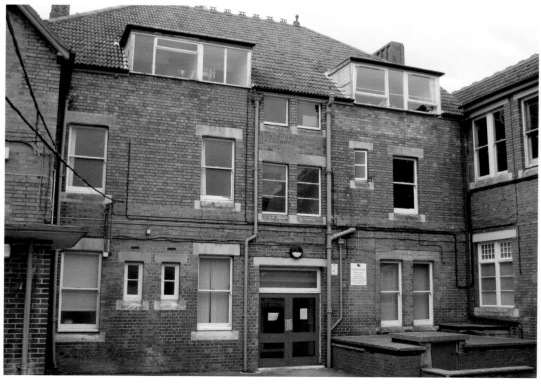

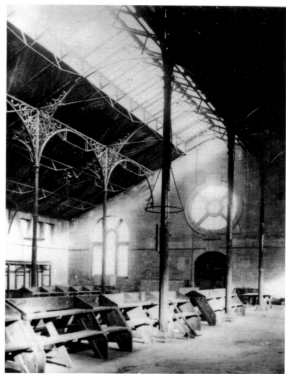

The Market Hall

Trowbridge has probably been a market town from before Norman times. The market was first held in Fore Street. The Market Hall opened on 30 September 1862 and was the gift of William Stancombe. It closed on 7 April 1973. Behind the hall was Market Yard, where a weekly cattle market was held until 1964. The Market Hall was replaced by the Castle Place Shopping Centre. The older picture is a very early view, and the modern view shows the fine exterior which is the only part of the original building remaining.

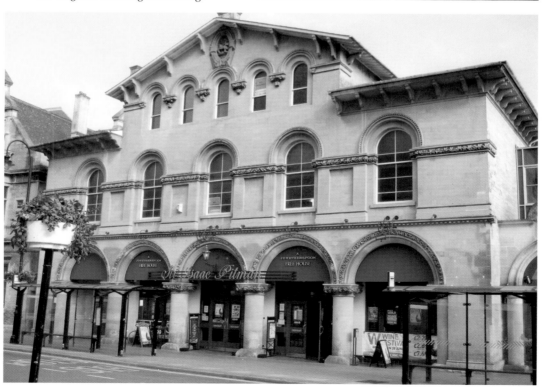

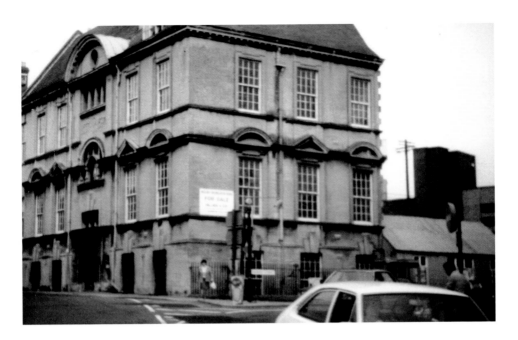

Victoria Technical Institute

The Victoria Technical Institute opened in 1902 as the town's commemoration of Queen Victoria's Diamond Jubilee. The foundation stone was laid in the Jubilee celebrations of 1897 and the cost of the building was £8,400. There were plans to extend the building, hence the stonework on the right-hand side and the temporary tin hut.

The building was first occupied by the county secondary day school. Then the textile school for which the building was built moved in! The town library used part of the building between 1932 and 1947. The textile school used the building with the commercial and technical school who were there between 1942 and 1969 (it is uncertain when the textile school closed). The institute was then used as council offices, then a magistrates' court. The Victoria Institute was demolished in 1984. A modern office/shopping block was later built on the site. Part was used by the Holloway Benefit Society when they left Holloway House (now Bridge House) in Stallard Street in 1985.

The George Inn (December 1980)
The first record of the George Inn was in 1467. The medieval building was re-fronted in the eighteenth century. For many years the inn was the main gathering place in the town. In October 1969 the residential section, comprising of twenty rooms, closed. The public house closed in December 1980. The building was then rebuilt and is now occupied by Clarks shoe shop. The area behind the George was the hotel's stable block and garages. Until the 1930s the George also had an open courtyard typical of old coaching inns, and this was converted into the Pine Lounge in October 1930. In the 1950s it became the panelled dining room.

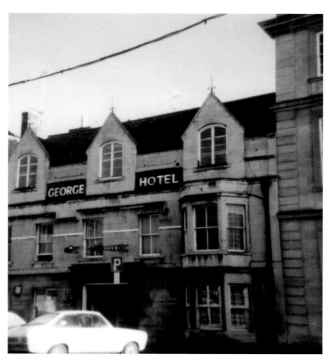

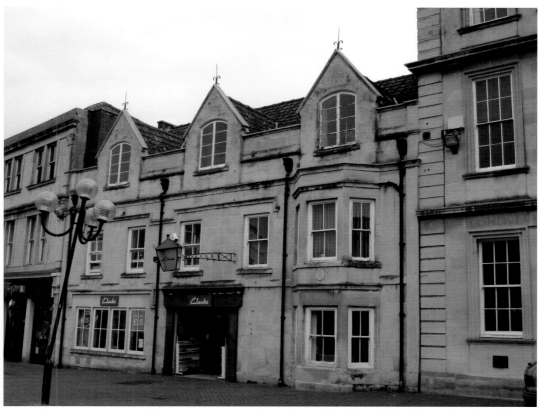

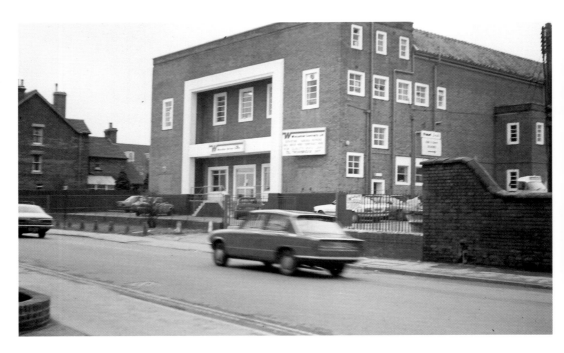

The Regal Cinema (1984)

The Regal Cinema, designed by Harold S. Scott, was opened at 2.20 p.m. on 1 November 1937 by Councillor Perkins Garlick JP, chairman of Trowbridge Urban District Council. The Regal could seat a total of 1,010 and closed on Saturday 19 November 1960. The building then had a variety of uses and is seen here when used by Wincanton. The modern photograph shows the new development by Parkridge.

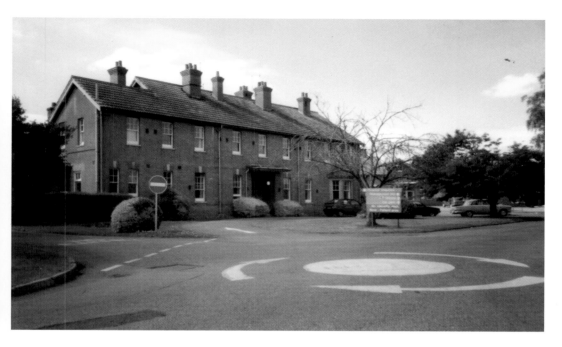

St John's Hospital, Bradley Road (1993)

A planning application was made in 1890 for an isolation hospital in Silver Street Lane. This hospital in Bradley Road was the Trowbridge Infectious Diseases Hospital from 1900 to 1948. In later years it became a geriatric hospital and headquarters of the local health authority before closing in 1997. This is another area now used for housing.

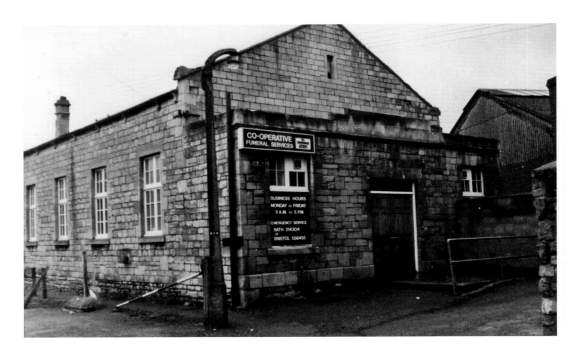

Co-op Hall, Castle Street

The Co-op hall stood behind the Woolpack (now Mastershoe). It was built in 1926 using stones from the old St Stephen's church in Castle Street which was demolished that year. The hall was available for private hire and also had a stage. The nearby commercial school, the Victoria Institute, used the hall on a regular basis and school dinners were served in the hall. The Co-op Funeral Services used the building in later years. The Co-op hall was demolished to make way for the Shires development.

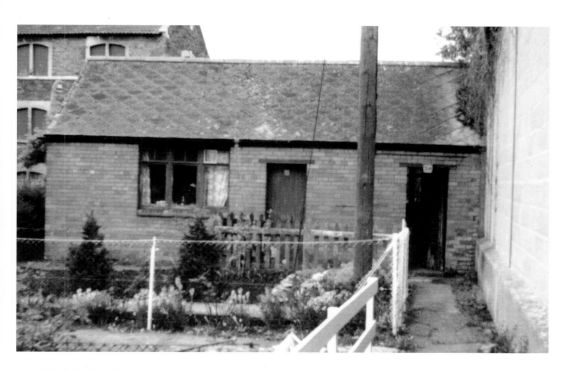

Toch H (1981)

This small building is part of Home Mill Buildings, near the Co-op Hall. It was a telephone exchange in 1925 and used latterly by Toch H. For many years Toch H sold second hand books and stamps here on Saturday mornings.

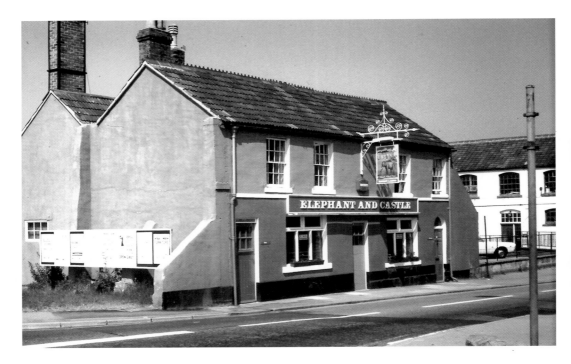

The Elephant and Castle Public House

This public house stood at the bottom of Castle Street, (opposite the houses seen in picture (page 12)). The last licensees were Mike and Sandra Henley. Following closure in the summer of 1991 it was badly damaged by fire in 1992 and subsequently demolished.

Frome Road Surgery

This building was erected *c.* 1960 on part of the land that Dr Henry owned. The small surgery was a branch of the Lovemead group practice and closed in the 1990s. The building had later uses which included car and mobile phone sales before its demolition.

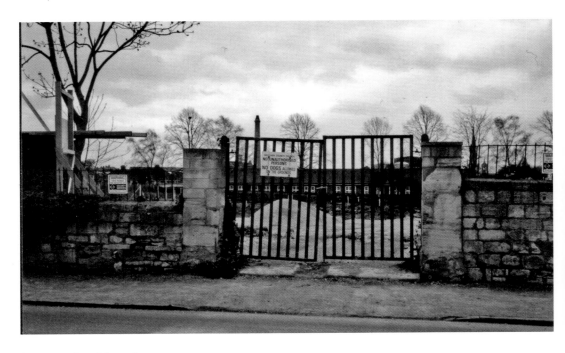

Seymour Road (1993)

These were the gates to the playing field of the Margaret Stancomb Infants' School, which was opened on February 19 1894 by J. F. Stancomb, who had donated the cost of the building. The school was transferred to Wiltshire County Council in 1908, and a further extension was made in 1931. The school closed in 2008 when it was combined with the parochial school on the Windermere Road site, now called the Bellefield school, which opened in 2009. The older photograph shows the start of the building of Charterhouse home.

The Adcroft Surgery, British Row (1990)

This doctor's surgery was for many years housed in a building that has long since gone. This was Trinity Villas, next to Trinity church, where the road now runs near the railway. A move was then made to Adcroft Villa in Adcroft Drive, where they remained until this surgery opened in 1991, built on an area of waste land at the side of the former Modoluxe Laundry. The ground behind was part of the county cricket ground and the houses seen are at the end of Seymour Road.

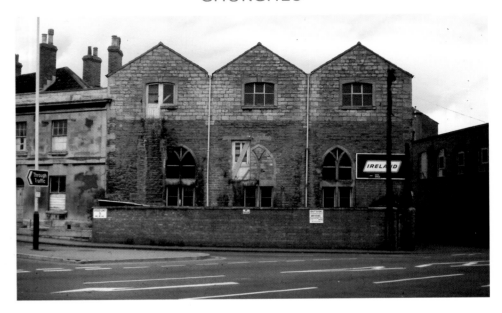

Buildings on the Town Bridge (1976)

This building was built as a Methodist chapel, which was used for many years as a wool store. It then became part of the Bowyers complex. John Wesley first preached in the town in 1754. In 1790 the Methodists built this chapel by the Town Bridge and it was enlarged in 1821. This photograph clearly shows the original windows. The upper part was added soon after the chapel closed and demolition took place in 1976.

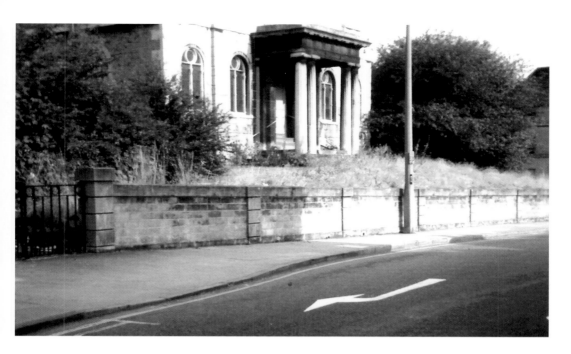

Manvers Street Chapel

This new Methodist chapel was built in 1835, by the congregation who were at that time worshipping in the old building by the Town Bridge. It was designed by a member of their congregation, John Dyer. In 1968 the Methodists joined with the congregation who were meeting at The Tabernacle, which was rebuilt 1882-3 forming the United Church. The Manvers Street building was then redundant and demolished in 1973. Part of the boundary wall still remains.

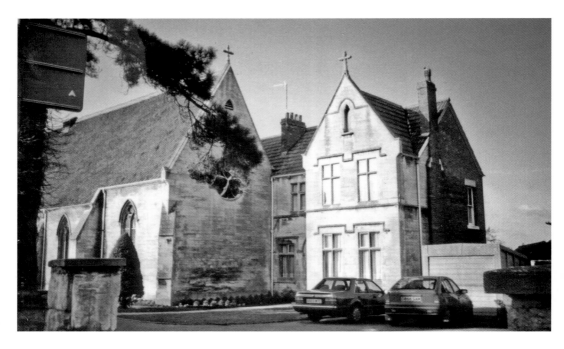

St John's Catholic Church, Wingfield Road

The Catholics in Trowbridge first met in a room at the back of the Anchor and Hope public house in Frome Road, before St John's Catholic church was built of stone in the Gothic style in 1875, in Wingfield Road. It was enlarged in 1907 with the building of the porch, and further enlarged in 1991 when the adjoining presbytery was demolished. A house was built at the rear enabling a road to be extended to the former St John's School, now the St John's Centre.

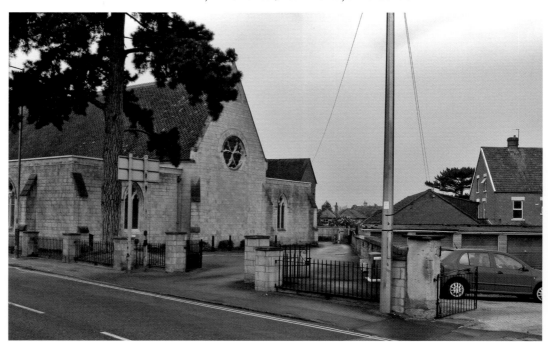

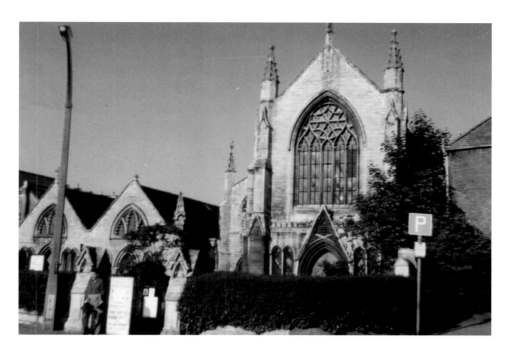

The Conigre Chapel (April 1978)

This Unitarian chapel was built around 1856 in the Gothic style, replacing a much older building. The architect was William Smith. The congregation worshipped here until 1972, but by then the building was proving too large to maintain so they moved into the adjoining schoolrooms. The chapel building deteriorated and was demolished in March 1988. The congregation moved to a small bungalow in Seymour Road and the schoolrooms are now used by the Bethel United Church who reopened them in 1993.

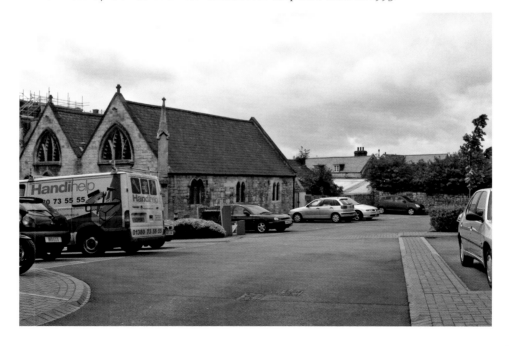

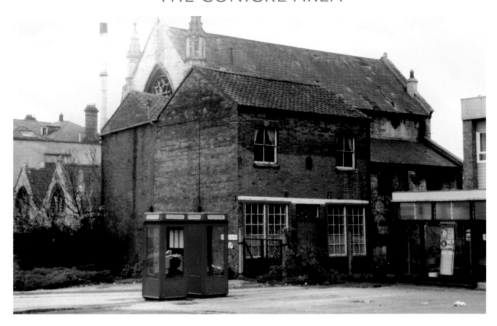

Middle Rank (1981)

This picture shows the buildings adjoining the Conigre Chapel. The house was used by the chapel warden. Middle Rank ran behind the bus station to Shails Lane. There was a row of houses along the footpath before the bus station. The end of the bus station waiting room and 'phone boxes are also seen in photograph on the next page. The name conigre means 'rabbit warren' and was an area of seventeenth-century houses. In 1933 there were 140 households in the area.

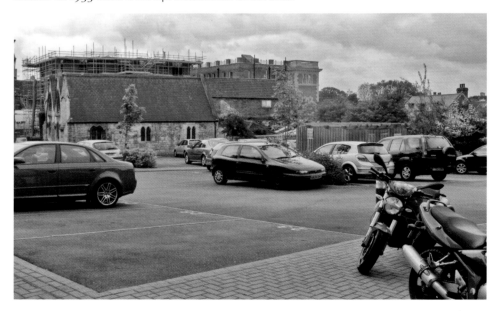

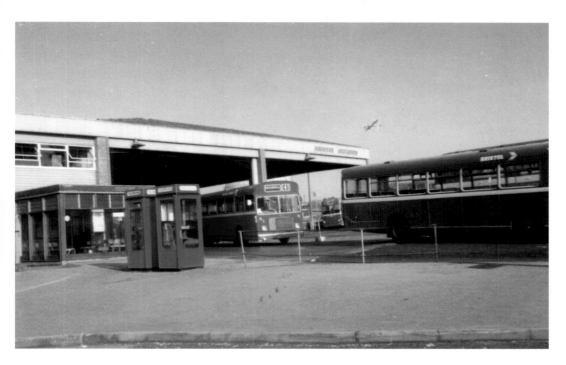

The Bus Station in the Conigre (April 1978)

The bus station in the Conigre was opened by Mr Denis Mugford on 24 March 1958 and closed on 3 April 1983. At that time twenty-two drivers, one inspector and five fitters were based at the bus station. After closure, the main departure site reverted to Market Street, as it was before 1958.

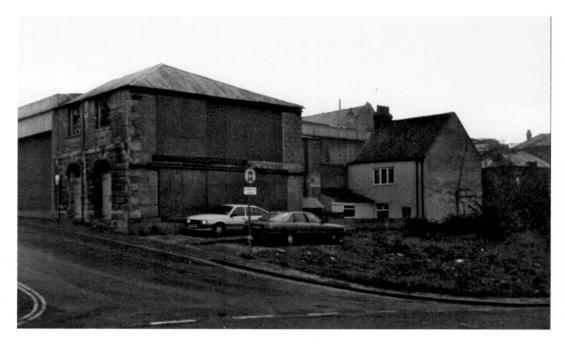

The Old Conigre School (February 1988)

This was another building remaining after the Conigre clearance. It stood next to the bus station in Lower Broad Street. The building was an infant school in 1833 admitting children at the age of two(!) and closed in 1907. In 1913 the building was a handicraft centre. At some stage the upper storey was removed. Much later it was used by James Ladd as a paint store. The building remained until 1988. The house seen in the old photograph (on the right) is the back of that seen on the next page.

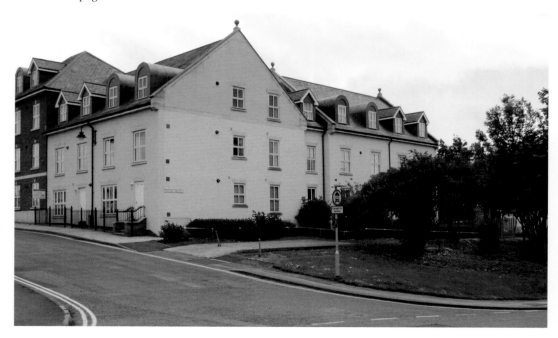

Middle Rank (February 1988)

Following the Conigre slum clearance of the 1930s many families moved to the first part of the new Seymour Estate, nicknamed Chinatown! This was opened in July 1935 by Geoffrey Shakespeare MP. In 1958 there were still twenty households in the Conigre area. The last house was occupied by Mr and Mrs Paradise who lived here into the 1980s. The steps up to Middle Rank remain, as does the name on the electricity substation.

THE SHIRES SHOPPING CENTRE

This opened in April 1990 and changed much of the centre of the town.

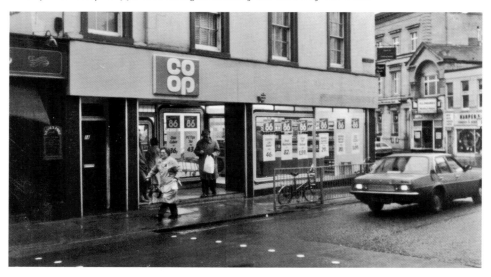

Co-op Supermarket (March 1986)

The Trowbridge Co-op ran many shops in the town. This shop was opened in 1887 as a meat and boot store, then divided into two areas it became the Co-op Boot, Outfitting and Butchery Department. The building was reopened as a Co-op supermarket in 1968. The Shires Shopping Centre entrance was made through the shop after the supermarket closed, and the Shires opened in April 1990.

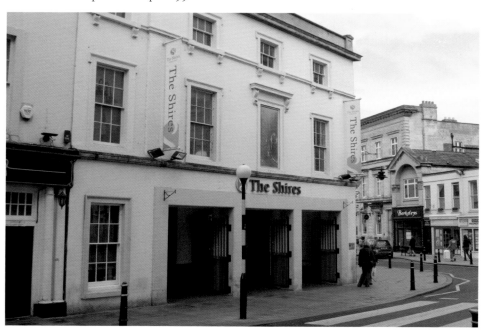

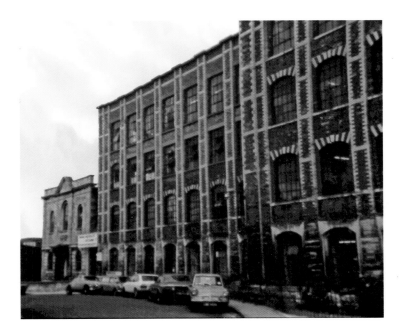

Salter's Factory in Court Street (1980)

Home Mills was the factory of Samuel Salter and Co. The factory was rebuilt following a fire in 1862 and then largely rebuilt again following a subsequent fire in August 1931. The windows, which are the originals, have brick surrounds while the windows replaced after the fire have concrete lintels. The upper storey was not rebuilt. In the distance can be seen what was until 1930 the Bethesda Baptist chapel, built in 1823 as a cost of £2,220. Salter's was the last Trowbridge cloth mill, closing in July 1982 with the loss of eighty-four jobs. It was put on the market with an asking price in excess of £200,000. The upper part of the factory now houses the Trowbridge Museum, which tells the story of the town and the woollen industry and opened in July 1990.

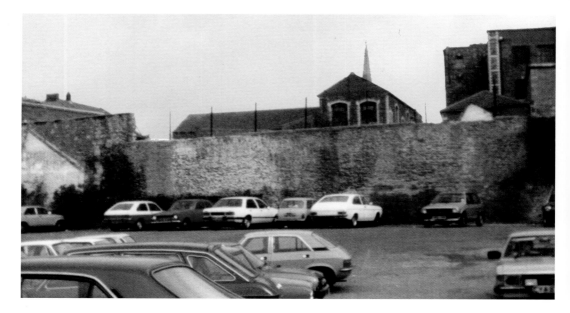

Gateway Car Park (1987)

This view shows the car park behind the former Gateway Supermarket and Mills Chemist, on the Town Bridge (now Brewers, Connexions and Pet Planet). These shops were built in 1969 when the mill buildings on the site were demolished. These had been occupied since 1897 when Sainsbury Seed Mills took over Bridge Mills. The picture shows the old wall of the factory buildings. Bridge Mills were first recorded as being on this site in 1808. The location of wall was thought to be part of the boundary of the Trowbridge Castle site.

**Massey's Printers
Castle Street (1980)**
This building was for many years Massey & Co. Printers works. After closure, the building was badly damaged in a fire in December 1979 and then demolished. The area is now a service area for the Shires shopping centre.

INSET: At the rear of the Massey building was the Co-op Model Bakery, which is here seen in 1980. It was opened in April 1903 by Mr E. Ponting (president of Trowbridge Co-op). In 1911 the bakery had the capacity to knead two sacks of flour into dough in less then ten minutes. The Co-op Model Dairy was also here.

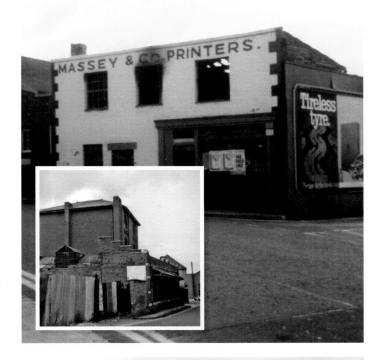

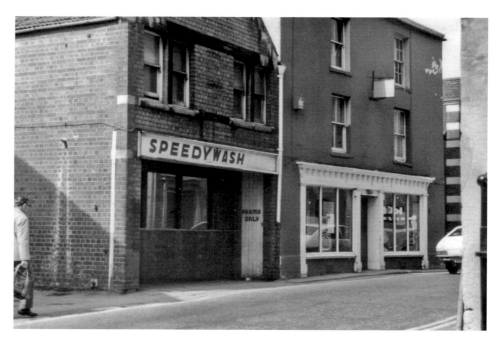

The Old Fire Station at No. 7 Castle Street (1984)

This building (Speedywash) was the town fire station from 1901. The brigade remained here until the outbreak of the Second World War when they moved to the county cricket ground at Prospect Place. The fire station building remains at the rear of the cricket pavilion. The building seen here was demolished as part of the Shires development in November 1988. The end of the Salvation Army citadel is seen on the right in both photos.

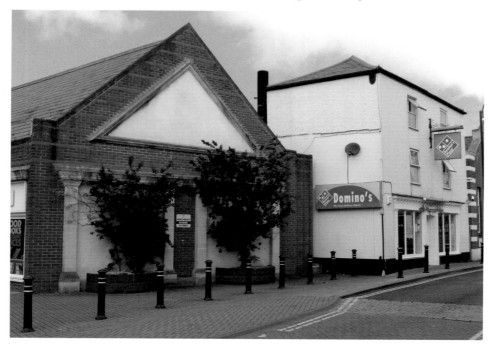

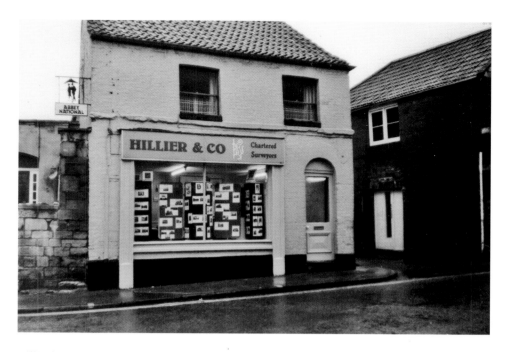

Hillier's Estate Agents at No. 9 Castle Street (1984)

The last occupiers of this building were Hillier and Co. Estate Agents; previous to this the *Bristol Evening Post* had offices here. This shop also went during the building of the Shires and the area is now the Shires entrance at the junction of Castle Street and Market Street. On the right hand is the building seen on page 64.

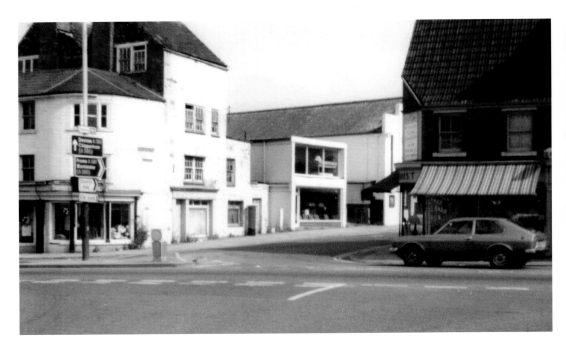

The Corner of Bythesea Road and Stallard Street

Bythesea Road, named after Henry Bythesea, was formed in 1903. This view shows the corner of Stallard Street, on the left a shop that was for many years Hiscock and Pinkernell sweet shop. Beyond that is a more recent building which was at one time occupied by Tanya's hairdressers, then became a bargain shop; beyond this was the Kinema. These buildings were demolished in November 1987 for the Shires development. On the opposite side the building still standing was Holland's Florist shop.

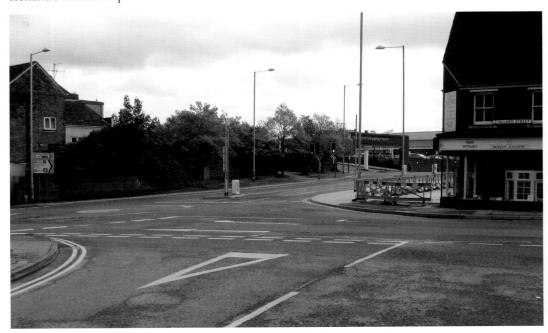

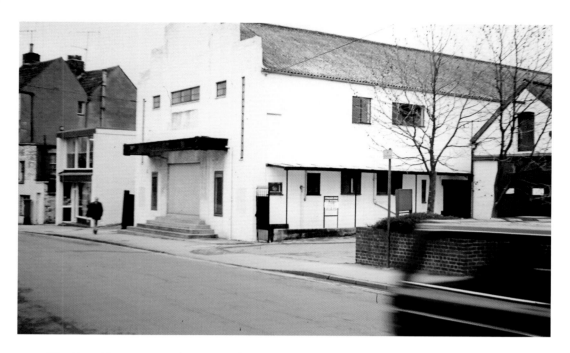

The New Kinema on Bythesea Road

This cinema was opened on 19 December 1934 by Mr C. Haden. Technical difficulties on that evening meant that the sound apparatus broke down and the performance was abandoned. On 17 May 1952, the New Kinema closed for renovation. It was re-opened shortly afterwards by a new owner. The cinema was renamed the Focus and opened on 14 July 1952, but it closed within a year on 23 May 1953. The building was then occupied by Denis Mugford & Co. estate agents. This is now the entrance to Adsa car park.

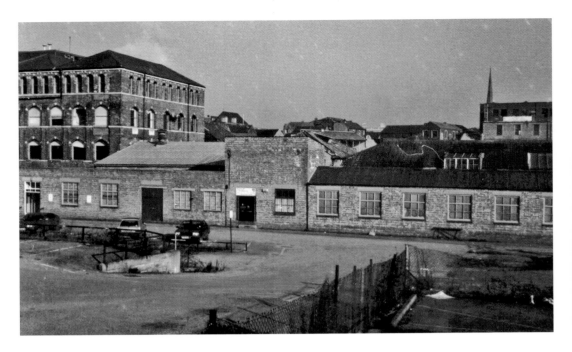

Studley Mill and Town Bridge

The oldest building remaining on this site is Bridge House of 1740. The area was re-developed by John and Thomas Clark in 1860, and the builders were the Gane Brothers. Clarks Cloth Factory closed in 1970 when the business moved to Stone and Home Mills, (Salter's page 61) seen on the right hand in the background. The massive decorated brick chimney built by Culverhouse in 1878, was removed in 1972. Although some buildings remain the rest of the area is now part of the Shires area.

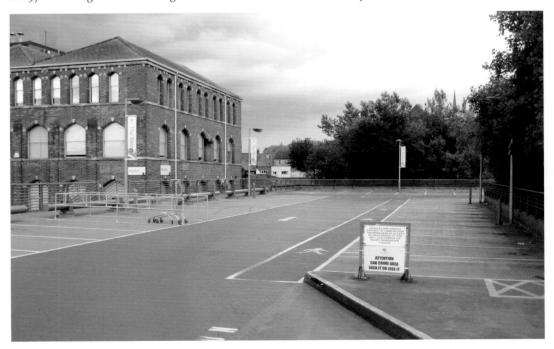

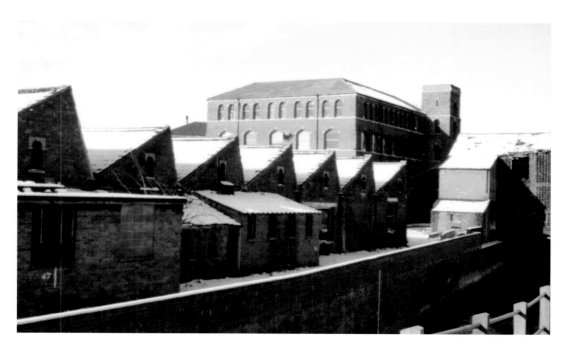

Studley Mill Weaving Sheds (December 1984)

This view shows the handle house on the right-hand side, built *c.* 1845 for the drying of teazels which were used to raise the nap on the cloth, and Clarks weaving sheds of 1865. These buildings were fast deteriorating in the 1980s. The Shires development on much of this area resulted in the Shires shopping centre opening on 10 April 1990, although phase one, the present Asda (then Gateway) supermarket, opened in the spring of 1989.

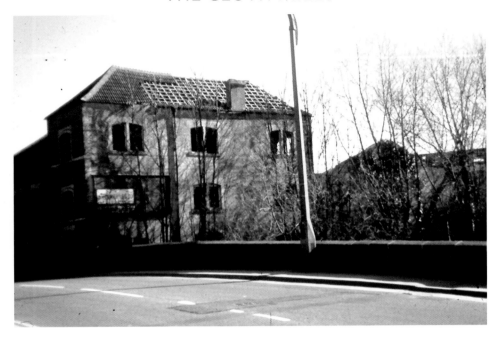

Cradle Bridge (1980)

Three mills remained in use at the start of our period. These were: Studley Mills, Stallard Street (see page 68), Salter's in Court Street (see page 61) and McCalls Mills in Castle Street. This is Victoria Mill which formed part of the MaCalls Mill complex. The site across the river was occupied by Zotos, then Peter Black Toiletries. Cradle Bridge was a wooden footbridge until 1850, when it was replaced by a road bridge.

The Demolition of MaCalls Factory (1980)

This mill closed in 1974 and was demolished in 1980. The site was then occupied by Tesco who built a new 30,000 square foot store which opened in November 1982 at a cost of £2.5 million. After this closed in the early 1990s the Tesco building was demolished and the site has been empty since then. The site is known to locals as 'Mount Crushmore'. In the background on both pictures are the 'new' spinning sheds.

INSET: MaCalls Mill Entrance (1980)

This was on the road leading toward Cradle Bridge.

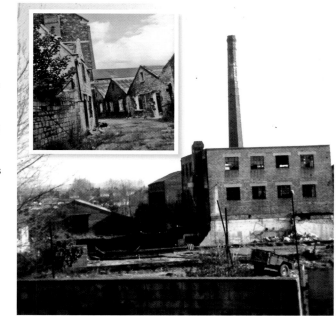

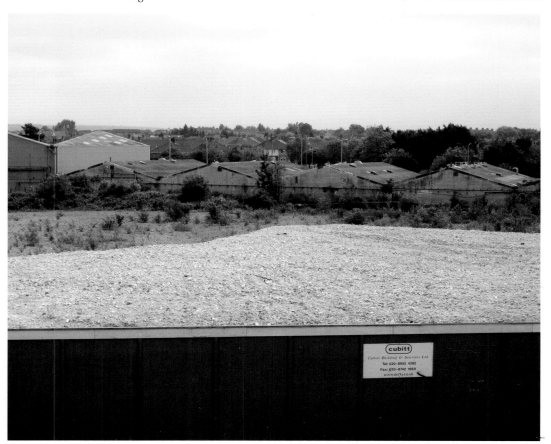

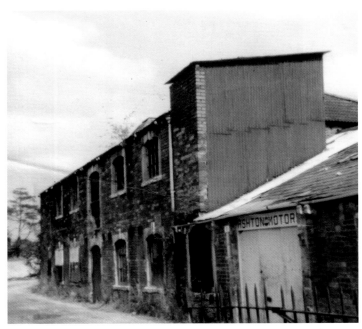

Ashton Mill Buildings (1980)

When built in 1860, Ashton Mill was in the parish of Steeple Ashton. It was run under the company name of Brown and Palmer, then Palmer and Mackay who ran this mill with the adjoining Court Mills until their closure in 1963. The 125 foot (38m) chimney was demolished in April 1984. This picture shows some of the outer buildings when they were used by Ashton Motors. It is thought that these buildings were on the site of County Way.

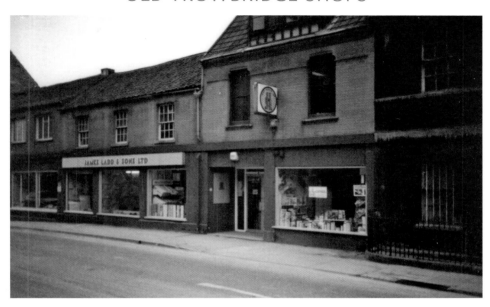

James Ladd's Shop in Hill Street

James Ladd opened a builders' merchants in 1934. It started in a house in Hill Street with sheds in the garden, and over the years the firm expanded and they also had a yard in Bradford Road. The business was sold by the Ladd family, and the Hill Street branch closed in 1990 when the business moved completely to the Bradford Road site, which today trades under the name Travis Perkins. James Ladd, MBE, died in January 1989.

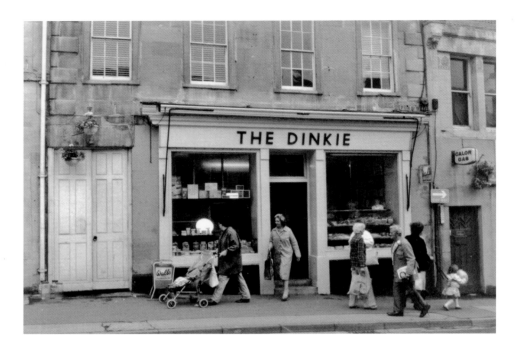

The Dinkie at No. 1 Fore Street (1986)

The Dinkie, opened by Harry T. Woods in 1922 at no. 5 Fore Street as a high-class fruiterer and cake shop, later moved to this shop at no. 1 Fore Street. The firm was later owned by the Wilkins family. This was a popular shop where both authors bought their favourite sweets including 1*d* lollies! The Wilkins family stopped trading about 1986. The shop later became a second–hand shop before becoming solicitors' offices.

Frederick Tranter Shop, No. 5 Fore Street (1979)

This shop area was part of the office block of Salter and Co. which replaced two gabled houses that were burnt down in the Salter's fire of 1862. Since 1914 this shop had been a tobacconist shop trading under the name of Tranter since 1948. The shop closed in 1979 and became part of the adjoining opticians.

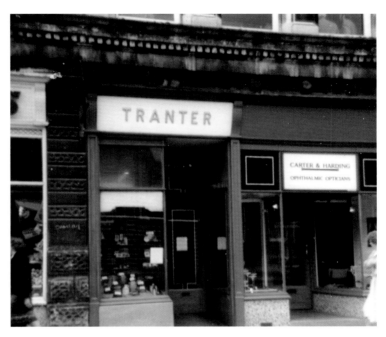

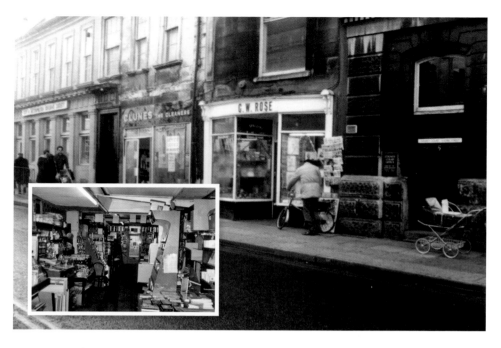

C. W. Rose Shop, No. 6 Fore Street

This building was the remaining half of two houses, the other half of which was demolished after a fire of 1862. Rose's stationery shop first opened in Church Street in 1883 and then moved to no. 66 Fore Street (the Crowing Cock) before moving over the road to a double-fronted shop. During the depression lack of trade forced the firm to sell half of the building, which was taken over by dry cleaners. The business closed some years after the Rose family sold it in 1985. *INSET:* the inside of the shop looking towards the front door.

W. H. Smith Area (1979)
This view shows three buildings (left to right): the White Hart pub, Hilser and Son jewellery shop (which was opened in 1909 and closed in 1973) and the Market Tavern (closed in 1971). This area was redeveloped to form White Hart Yard, which opened in 1981, when W. H. Smiths moved from no. 52 Fore Street, a site they had occupied since 1923 when they had moved from Stallard Street where the first W. H. Smith in the town opened in 1905.

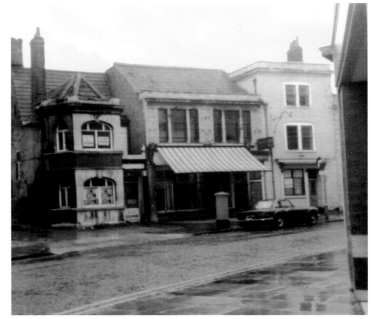

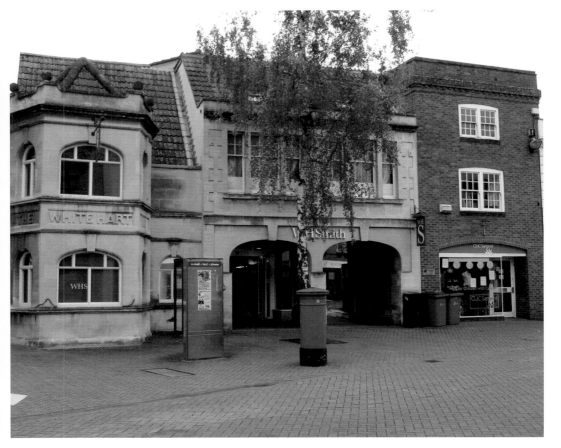

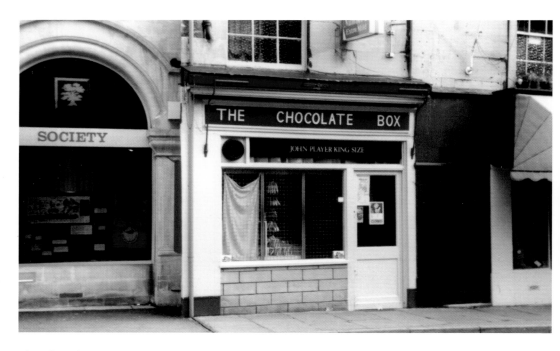

The Chocolate Box at No. 38a Fore Street (1981)

This small shop was opened before 1950, and was for many years owned by the Riddiford family. Before the relaxing of Sunday trading laws this was the only shop to open in the town on a Sunday, and children would buy sweets on their way to afternoon Sunday school! The building, a small shop on the end of a row, was rebuilt along with others on the corner opposite the town hall in 1986.

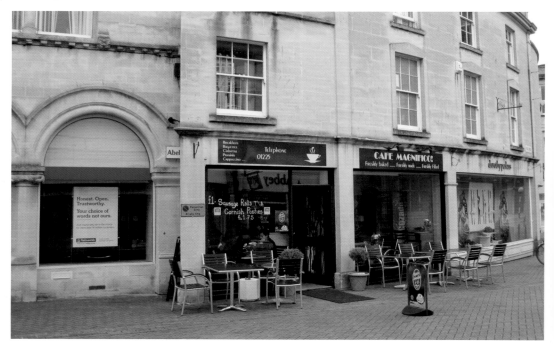

The Co-op at No. 3 Castle Street (1978)
This was one of two Co-op shops in Castle Street, next door at no. 4 was the Co-op seed shop. Both had stood empty for an number of years prior to this photo, but has now been replaced by a building society.

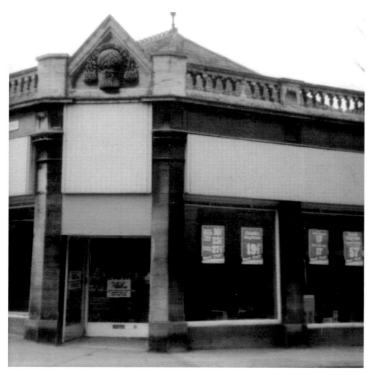

The Co-op at the Corner of Newtown and Gloucester Road (1980) The Co-operative movement in Trowbridge began in 1861. Over the years many stores have existed in the town and Rodney House, Roundstone Street, was the head office. The shop here in Newtown was built in 1908, when the president of the society, Mr H. J. Pollard, opened the new store in July that year and a tea and gala was provided for the children of the Penny Bank. The Co-op store closed in 1980 and the building was taken over as an auto-spares shop.

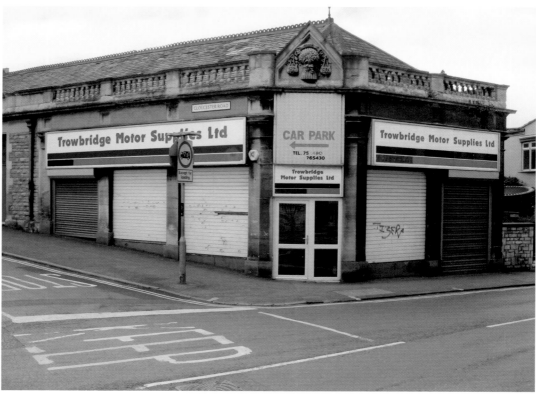

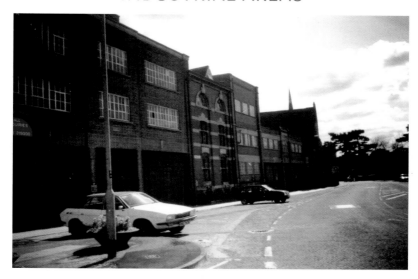

Ushers Brewery, Union Street (1993)

Thomas Usher began his brewery business in the town in 1824. For many years Ushers Brewery had three sites in the town; (1) The Back Street premises at the rear of the parade (2) The Conigre Site and (3) The Union Street site. Part of the Union Street site was run by J. H. and H. Blake Brewery until they were absorbed into Ushers in 1923. This area formed the bottling stores built on the site of The Royal Oak in 1954. Further pre-war buildings extended down the road to the former St James Hall. These buildings were all demolished in 1997. The houses were built in 1999. Ushers brewery finally closed in 2000.

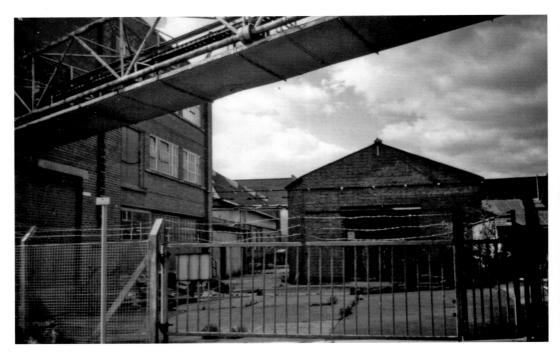

Ushers Bottling Stores in Duke Street (1991)
This view is taken directly behind Zion Chapel and shows the rear of the bottling stores, the building on the left is the same as that in the distance on the next page. The conveyor bridge was added in April 1971 to move bottles from the unloading bay to the bottling hall.

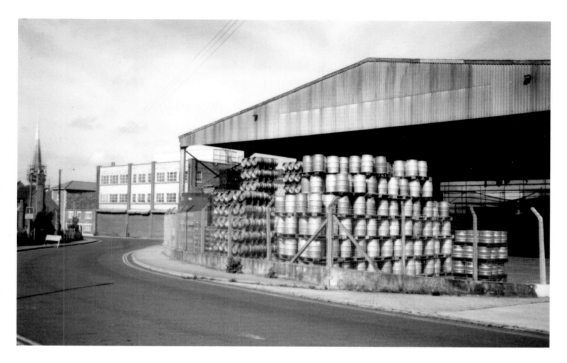

Duke Street (1990)

The first view again shows part of Ushers bottling stores. Until 1965, Duke Street ended just beyond the *Wiltshire Times* premises. The demolition of Duke House enabled the road to be extended to The Halve and the construction of the car park. The houses which now occupy this area were built in 1999.

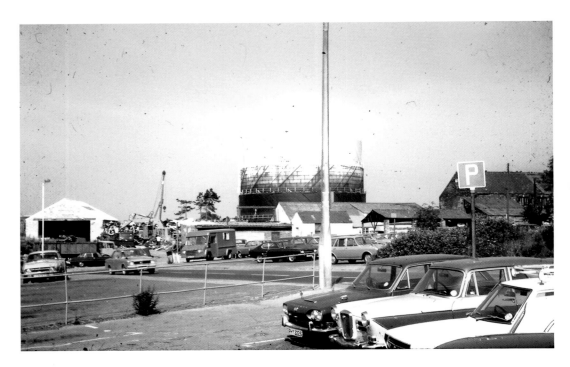

The Gas Works (1976)

The manufacture of coal gas in the town began in 1824. The town's gas works were in the area fronted by Gas Works Lane (now Riverway) and Shails Lane. There were several gasometers, and our picture shows the last one in a view taken looking across the Conigre. Several of the buildings remain, either as part of E. J. Shanleys and Sons (Trowbridge Ltd) scrap yard, or as industrial buildings in Riverway.

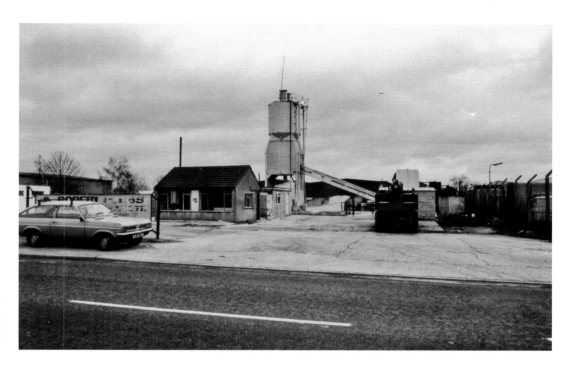

Canal Road (1987)

This site was a cement mixing works, under the name of Hobbs in 1987. When the photo was taken the last owners were Topmix who occupied the site in 1998. The site was used in 1973 by post office engineers. This is now the Hills Mineral and Waste Ltd public recycling site.

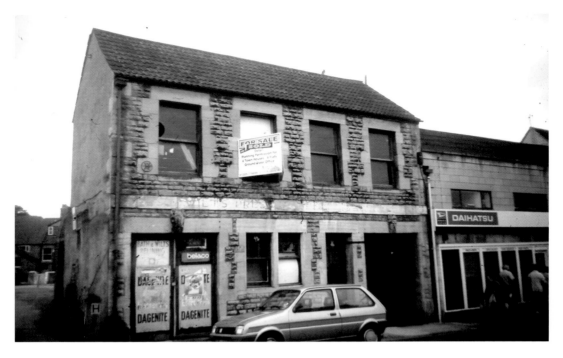

No. 11 Duke Street (1993)

This building was the West Wilts Press Printing works. By 1962 the building was occupied by Raybestos Bath and Wilts Relining Services. It was suddenly demolished in the 1990s. The building was later rebuilt and is now occupied by the funeral directors Patrik Bewley.

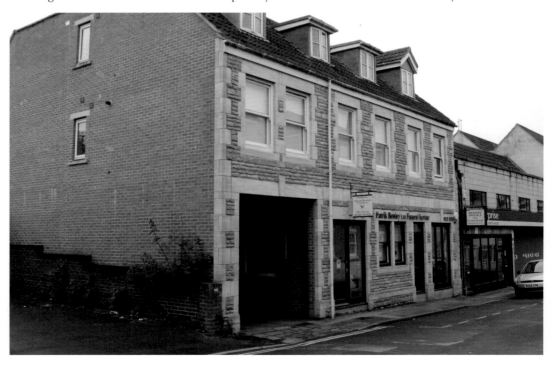

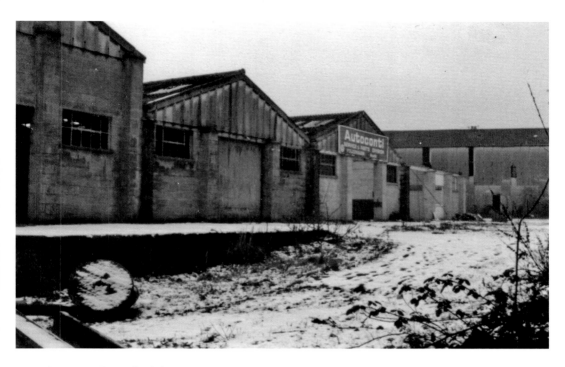

Seymour Court (1985)

This site had buildings which were used by the motor traders Autoconti. A planning application was made in around 1984 and the area is now covered in houses.

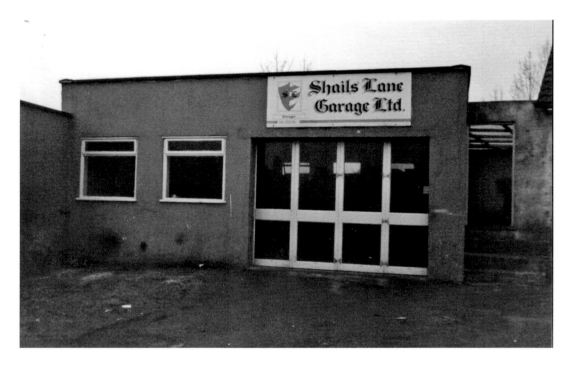

Shails Lane Garage Ltd (1988)

This garage was in use in the 1970s and '80s, and the adjoining bungalow was occupied by the owner. A planning application was approved in 1988, and Helens Court flats now occupy the site.

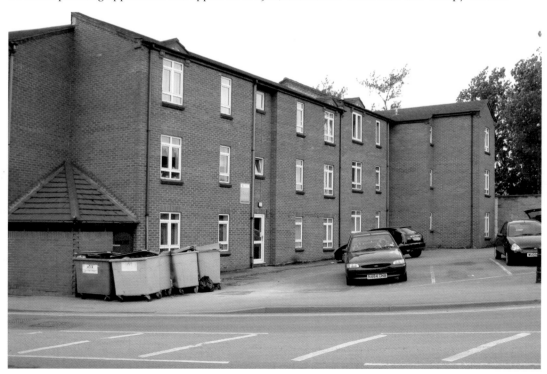

Mill Street (1992)

By 1953 Jack Plowright had a motorcycle firm based here that remained until the 1980s. After Plowrights closed the building was a second-hand furniture shop among other things. In 2004 Sarsen Housing Association built new homes here.

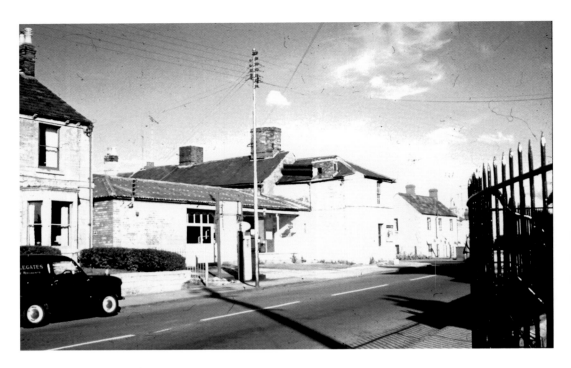

Newtown/Frome Road

This photo of the junction of Newtown and Frome Road shows an existing house, no. 61 Newtown next to which was the buildings used by Sleightholme and Sons Motorcycle Business before their move to Frome Road in 1963.

Mortimer Street Garage

The demolition of the houses on the outer side of Mortimer Street began in 1925 when nos. 123 and 125 were demolished to make way for Drinkwater's motor showroom. The other houses near here were all standing in 1953. Ten years later, of these only nos. 121 and 122 remained. In 1960 these were demolished and a filling station built. The garage remained in use until at least the early 1990s. After the garage closed the site had other uses, including a plant hire centre, and it is now occupied by housing and car parking.

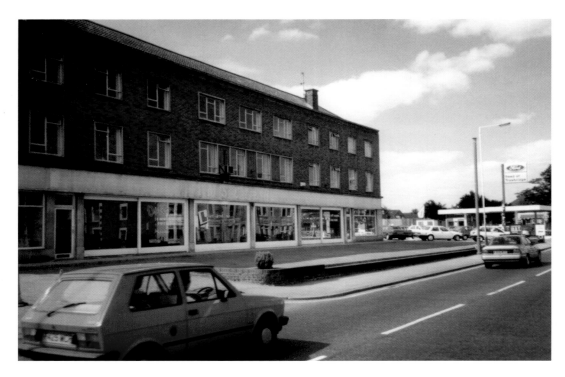

Car Sales Area in Bradley Road (1993)

This site was developed in the 1930s when Ernest Dennis expanded his Castle Street business. This was used for Spitfire production (see next page). The 1960s building seen in the first picture was used by Ramseyers Motors later Vick Bros. and latterly Reeds until moving to Canal Road.

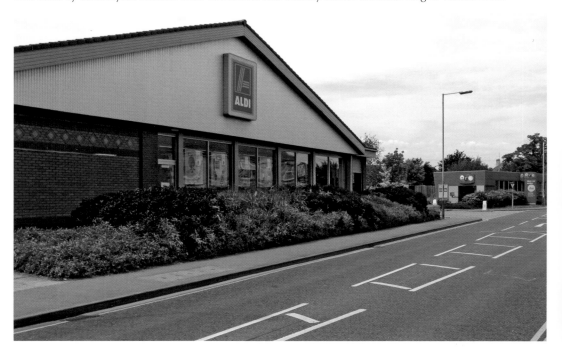

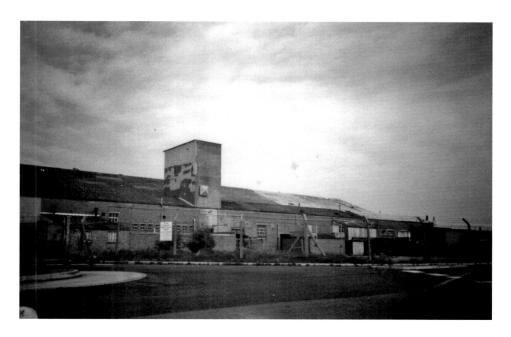

Hattersly Heaton in Bradley Road (1995)

RAF production of Spitfire aircraft was based at the Supermarine factory in Woolston Southampton. These works destroyed in an air raid in September 1940. Alterative sites were found across southern England. Here the fuselages were built, and engines installed and wings completed. The planes were then taken to Keevil Airfield for assembly and testing. Aircraft assembly continued on this site until 1958. The building then in 1959 became an engineering works, Newman Henders, later, Hattersly Heaton, until closure in 1992. The factory was demolished in 1996 when the present retail park opened.

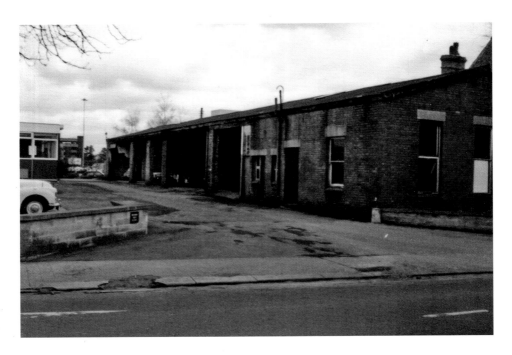

Isley Builders in Bythesea Road

These buildings in Bythesea Road were for many years occupied by the firm of Herbert Isley, one of the major building firms in the town. A far as it is known, their offices were in the building which is now the Bustard Club. It is not clear when the firm closed, however, some of these buildings were later used by the county council after the county hall fire of 1958.

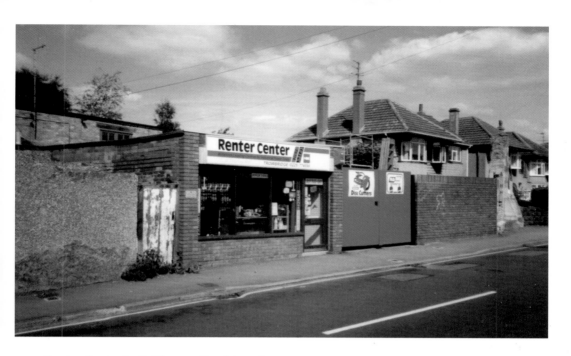

Renter Center in St Thomas Road (1993)
This building was a tool-hire shop for some time. St Thomas Road was built in the 1930s over parkland belonging to Bellefield House. The archway to St Thomas' church can be seen on the right.

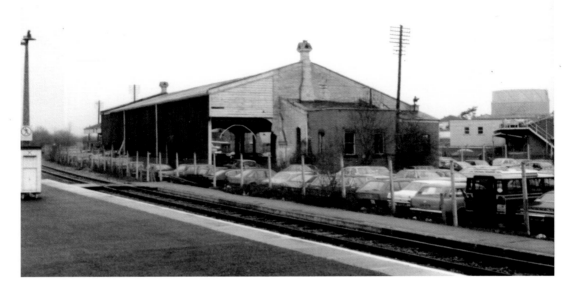

Railway Goods' Shed (1985)

This photograph shows the goods shed, which was part of a large complex of buildings and sidings occupying the area, from the railway across the former Bowyers site, which may be seen in the right-hand background. For many years Trowbridge was an important railway goods centre. The goods' depot was a fine example of a Brunel design, closed on 10 July 1967, and was demolished in April 1985. A car park now is on the site.

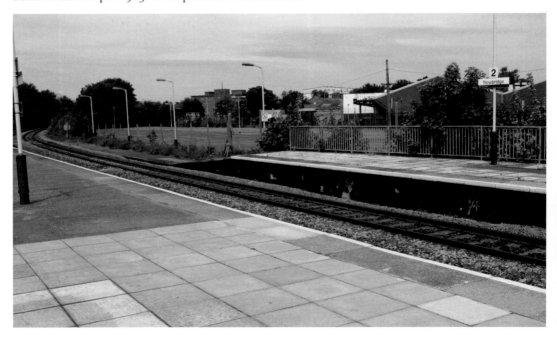